BALLOON
OVER BRITAIN

For Leo and Francesca

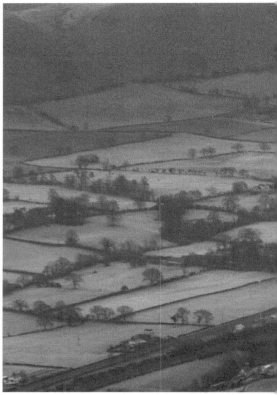

BALLOON
OVER BRITAIN

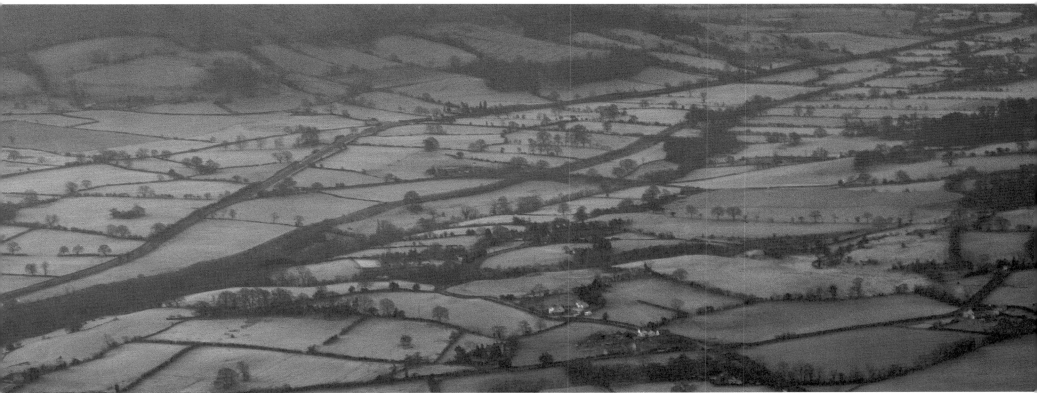

PHOTOGRAPHS AND TEXT BY ANGELO HORNAK

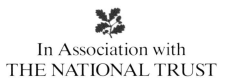

In Association with
THE NATIONAL TRUST

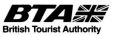
British Tourist Authority

EDITOR Wendy Boase
ART EDITOR Bryn Reynolds

First published 1991 by Walker Books Ltd
87 Vauxhall Walk, London SE11 5HJ
in association with The National Trust
36 Queen Anne's Gate, London SW1H 9AS

First printed 1991
Printed and bound by L.E.G.O., Vicenza, Italy

British Library Cataloguing in Publication Data
Hornak, Angelo
Balloon over Britain.
1. England
I. Title
942.085'8

ISBN 0-7445-0444-9

ACKNOWLEDGEMENTS

I would like to thank Sebastian Walker for his generosity and patient encouragement. I am also indebted to my fellow balloonists, without whose help and support I would never have got this project off the ground. Particular thanks go to Christine Allen, Graeme Clark, Tom Donnelly, Chris Frampton, Ravinder Hunjan, Miguel Nadal, Tony Patey, Max Steuer and John Yarrow. Thank you all, and everybody else who has accompanied me on my crazy expeditions, getting up at dawn, trailing all over the country, and putting up with the impossible demands of ballooning photography.

I would also like to thank all the owners of country houses who allowed me to fly from their parks – in particular, the owners of Longleat, Castle Howard, Chatsworth and Blenheim Palace. The photographs of Blenheim Palace on pages 108-9 are reproduced by kind permission of His Grace the Duke of Marlborough, J.P. D.L. My thanks also to the many landowners, farmers and National Trust staff and tenants who let me use their land as a launch site. And, with one or two exceptions, I want to thank the farmers on whose fields I dropped unannounced, for being so friendly and hospitable. Finally, I must thank Dr Marjorie Sweeting for her help with the Geology section and Lionel Brett for his kind permission to quote from *Lifting Off at Sunset*, a collection of poems published in 1986.

Camera Notes

The photographs have been taken on a variety of cameras and films. The cameras were a Plaubel 670 (for simplicity), a Pentax 6x7 (for easy handling) and a Rollei 6006 (for flexibility – motor drive, interchangeable backs and the 40mm Distagon lens). Almost all the photographs were taken on 120 film (Kodak and Fuji, fast and slow).

FOREWORD

Looking at Angelo Hornak's splendid photographs taken from his balloon, I get a feeling of countryside enfolded in golden calm. The preponderance of gold is because the best times to make balloon flights are in the early morning or late evening when there are no thermals and the air currents are at their most kindly. But I gather the calm is sometimes an illusion; travelling in a hot-air balloon can be a very noisy affair, with the gas jets flaming inches above one's head.

It has been fascinating to pore over the images of the British landscape shown here, many of them featuring properties belonging to The National Trust. Sites so familiar to the ground-based visitor acquire a surreal image from the air: I think now particularly of the curious pimples that are, in fact, burial barrows near Avebury in Wiltshire. Images of buildings take on a dramatic intensity: the symmetrical beauty of Sir Edward Dalyngrigge's late medieval castle at Bodiam in Sussex, caught my eye. So, too, do the country houses with their avenues radiating out into the park and beyond. Angelo has set his picture of Dyrham Park in Gloucestershire against the early eighteenth-century bird's-eye view of Kip and Knyffe. How Mr Knyffe would have appreciated the services of a hot-air balloon in undertaking his perspectives!

The National Trust is nearly one hundred years old. During the past century, it has striven to protect places of historic interest or natural beauty, acquired with the help of bequests, gifts and the support of its ever-increasing membership. The result is a unique range of properties: over half a million acres of countryside from mountainous landscapes like Snowdonia to stretches of flat coastline like Blakeney Point in Norfolk; over 200 historic houses from the neo-classical palace of Kedleston in Derbyshire to the tiny medieval priest's house in Alfriston in Sussex, the Trust's first purchase. This book cannot include a comprehensive survey of these properties – it could, for instance, prove fatal to try to take a balloon too close to the coast – but it gives a taste of some of the countryside and buildings cared for by The National Trust.

Jennifer Jenkins

CHAIRMAN OF THE NATIONAL TRUST
1986-1991

CONTENTS

When the world's first aeronauts, the Marquis d'Arlandes and Pilâtre de Roziers, floated away from the Château de la Muette in the Bois de Boulogne, in 1783, they were entranced by their bird's-eye view of the city of Paris. The Marquis was so excited by the sight of the Seine that he had to be prompted to stoke the fire that kept their balloon aloft with the threat: "If you gaze at the river like that you will soon be bathing in it. Some fire, my dear friend, some fire."

The aircraft which carried the intrepid balloonists on this first flight was built by the brothers Montgolfier, who were paper makers in the south of France. To this day, hot-air balloons are known as *Montgolfières* in France, but the modern hot-air balloon is a far cry from the Montgolfiers' constructions of cotton and paper, fuelled by throwing bundles of brandy-soaked straw on to an open brazier. Nowadays we rely on man-made fabrics and stainless steel wires of enormous strength and our powerful burners deliver controlled jets of flame safely inside the balloon's "envelope". But if the technology has changed, the sensation of flying is unaltered. Unlike an aeroplane, which only stays airborne because of its speed, a balloon literally floats – it wants to stay up. This gives a balloon flight a feeling of serenity even when the silence is broken by the occasional roar of the burner. When the balloon lifts off, there is no sensation of movement: the ground just drops gently away and you feel, in T. S. Eliot's words, "at the still point of a turning world". You can drift across a forest at tree-top height, picking leaves from the taller branches as you brush through them. You can even carry on a conversation with the people on the ground, such is the peace and tranquillity of a

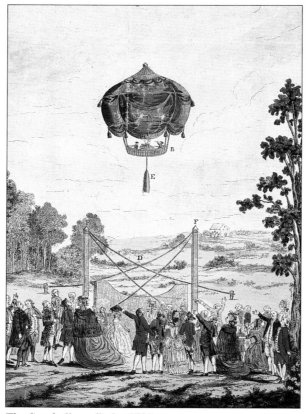

The first balloon flight, 1783

balloon flight. Or you can climb effortlessly to ten thousand feet with nothing more than a high-tech laundry basket between you and the earth below. You gaze down at the countryside and notice details you never expected: foxes slinking through the woods and hares engaged in boxing matches; you drift over Neolithic hillforts and eighteenth-century landscape parks; you drop down into glacial valleys and climb high over a range of volcanic hills. All this gives ballooning an intimacy with the landscape, which is one of its main charms.

This intimacy extends to the weather: you are held aloft by nothing more than a parcel of air wrapped up in a plastic bag and your parcel of air is very much part of all the other air around. You are taken over by the great restless atmosphere with its constant ebbing and flowing. In a balloon you are not only at the mercy of the elements, you become part of them. The balloon will only travel where the wind blows it. Unlike a ship at sea, you cannot tack into wind; in other words you cannot steer. If the wind changes direction, so do you. If the wind picks up in strength the balloon speeds up and landing becomes very tricky, maybe involving a long bumpy drag across a field. "Intimacy with the landscape" takes on a new meaning as you bounce from one cowpat to another, desperately trying to deflate the balloon before it wraps itself round a large oak tree or electricity pylon.

To launch a balloon successfully and to land it safely, wind speeds should be not much more than ten miles per hour. The calmest moments of the day are usually early in the morning or late in the afternoon, and these are the normal times for flying a balloon, when there is less risk of

turbulent conditions caused by thermal upcurrents: a balloon, unlike a glider, can generate its own heat and is actually made uncontrollable in thermal conditions. During the winter months, when the sun is lower in the sky, thermals are less of a problem and flying can take place all day long. Indeed, some of the most exhilarating flights are to be had on a frozen winter's day, with the air hardly stirring.

In a country already obsessed with the weather, balloonists are some of the most obsessive weather watchers. After a couple of hours in the company of balloonists, you soon learn to scan the countryside for the tell-tale signs of wind speed and direction: washing blowing around on a line, leaves shimmering as they rustle on the trees, strong ripples on the surface of small patches of water – these are all bad signs. But perhaps the wind will drop; balloonists driving to a launch site will turn their heads to study a factory chimney belching out smoke, hoping to see it drift lazily upwards, away from the sea or from controlled airspace. But not too lazily, because flat-calm conditions might lead to the balloon being marooned over some inhospitable feature, like a forest or a lake or, worst of all, high-voltage pylons.

But when the weather is right, a balloon flight is a "magical mystery tour". Although we can control the height of the balloon very precisely, we cannot say how far we will fly, how long it will take, where we will land, or what reception we will get from the farmer whose field we drop into. We can only plan our flight within the general wind speed and direction the forecasters give us.

The low-flying rules that govern aeroplanes apply to balloons as well. We must not fly below 1500 feet over a town or city, or we can be prosecuted by the Civil Aviation Authority. This is not usually a problem, as a couple of long blasts on the burner will send the balloon up to 1500 feet pretty quickly. Balloonists have to be especially careful near the coast, as once blown out to sea we are unlikely to be blown back again. The only control we have over direction is to use "wind shear" – the fact that winds at different heights blow in slightly different directions. If you gaze up at the sky, especially on a day when a blue sky is broken by different types of

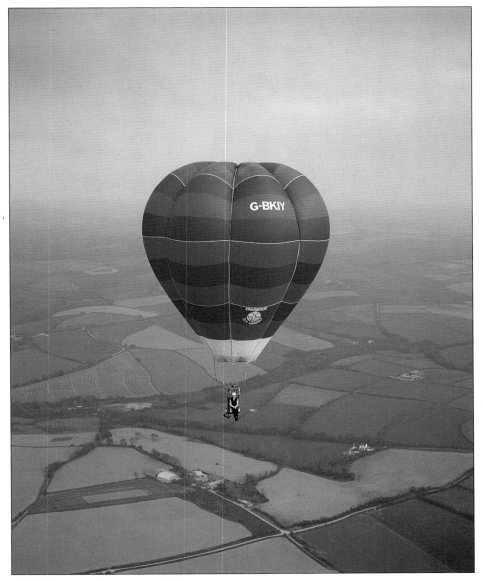

G-BKIY, my Sky Chariot, at 1000 feet

cloud, you will notice that not all the clouds move at the same speed nor in the same direction. The lower clouds usually travel at a tangent compared with the upper clouds. Since the clouds, like a hot-air balloon, can only travel with the wind, cloud movements are a very good indicator of wind speeds and direction. The lower winds are slowed down by friction with the Earth's surface, and the rotation of the Earth spinning on its axis deflects the lower winds from their "true" direction. In ballooning this is all summed up as "Right with Height". In general, the higher you fly, the more your track tends to go to the right. This is the only steerage we have.

I was once flying parallel to the south coast, heading towards Brighton with the sea two or three miles to my right. I wanted to land before I reached Brighton, but nowhere suitable turned up – all the fields were full of excitable cows and expensive horses, which would have been terrified if I had arrived in their fields snorting flames like a multicoloured dragon. So there was nothing for it but to fly over the northern edge of Brighton and hope for a good landing spot beyond the town, to the east. As I crossed the edge of the town, I dutifully climbed to 1500 feet; "Right with Height" became an uncomfortable reality, and the balloon began to

Cloudy conditions over the South Downs

drift over the centre of the town towards the beach. I found myself anxiously wondering whether there would be enough space to land on the beach (was it high tide?) or whether the coastline beyond Brighton dipped far enough to the right to allow me to pick up the land again before Eastbourne. Remembering that you are allowed to break the low-flying rules if you are "flying as may be necessary to save life" – Thank you, Rule 5 (9.4.3.[b])! – I brought the balloon down smartly to 500 feet, and was very relieved to find my track bending to the left away from the coast. I hope I didn't rudely shatter the Sunday morning lie-in of too many citizens as I kept the balloon level with regular short blasts from the burner. I proceeded to a graceful, and grateful, landing on the racecourse. Luckily there were no races in progress at half past eight in the morning!

Since a balloon cannot change its course at will, it is very important that we keep out of controlled airspace – in other words we have to be sure of not being blown towards airports. We can fly over small aerodromes at 2000 feet, but once heading for Heathrow or Gatwick, we must land before we get close to them. A large balloon drifting helplessly across the runways at Heathrow would cause some consternation among the jumbo pilots coming in to land. It is precisely because you cannot steer a balloon that navigation is such an important part of ballooning. For these reasons a balloon pilot needs to pass various exams, including a flight test, before he gets a licence to show, as it were, that he can plan the unplannable.

Accidents in ballooning are happily very rare, but any form of flying is more risky than staying in bed. We pay a lot of attention to the safety of the fuel systems. The fuel is propane: a nasty, smelly, explosive and generally dangerous gas. We treat it with great respect, as a propane fire in a hot-air balloon is a deadly proposition. Quite a lot of a pilot's training is devoted to the safe handling of propane; and provided the equipment is looked after and checked regularly, and the pilot remembers his training, then the risk is not too great.

Another big hazard in ballooning is the danger of flying into electricity cables and telephone wires, which are not always easy to see against the countryside, especially in failing light. When choosing a landing site, we

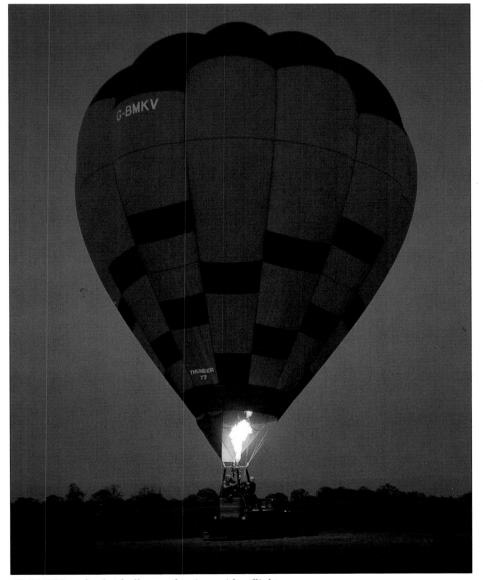

G-BMKV, my basket balloon, after its maiden flight

look very carefully to make sure that there are no wires running across it. The danger of flying into wires is increased in poor visibility and in turbulent wind conditions: in ballooning, the biggest safety factor is the weather. All airmen are taught early on that "It is better to be down here wishing you were up there than up there wishing you were down here!" But balloons are very forgiving and anyway, the slight edge of danger is part of the thrill: the surge of adrenalin as the balloon touches down contributes to the excitement.

To enjoy ballooning calls for a spirit of adventure. But its real charm, its irresistible appeal for me, comes from its unpredictability. You fly off in a basket dangling beneath a plastic bag full of hot air, not knowing where you will end up. Perhaps this seems ludicrous and preposterous to most people, but to the addicted balloonist this surrender to the unknown is exactly what gives it its thrill.

On the face of it, this would hardly seem a promising formula for photography. The aerial photographer usually has a specific subject that he wants to photograph. On a clear, sunny day he goes to the local airport and climbs into a small plane or a helicopter, tells the pilot, "Fly to Ashdown House," or wherever. The pilot takes off, flies straight there, does a few circuits round the house with the photographer clicking away through the door or window, and then they fly back to the airport. If I want to get photographs of Ashdown from my balloon, I have to approach the owner of the house – in this case, The National Trust – and ask for permission to launch the balloon from the grounds. As soon as the weather looks promising, I have a hectic time making lots of telephone calls to try to put my plan into action. I need to check with the Meteorological Office that the weather really is suitable, then I need to gather one or two friends together as crew, and alert the house that I am on my way. If this all works out, we set off for Berkshire and hope the weather is still favourable by the time we get there. Our arrival is followed by the performance of unloading the balloon from its trailer, laying it all out on the ground, inflating it with cold air from a powerful fan and, finally, heating it up to the point where it is buoyant. But balloon photography is a frustrating

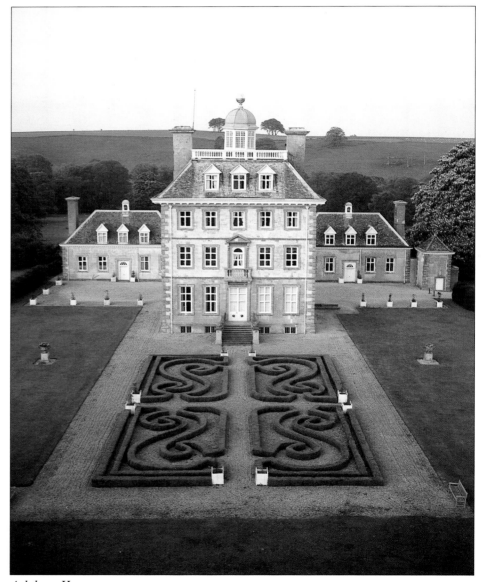

Ashdown House (THE NATIONAL TRUST)

business: at this moment the sun usually goes in, or the wind changes direction once I'm airborne and blows me over the wrong side of the house and straight out of the park before I can get any photographs.

But when everything works out, a balloon makes a wonderful camera platform. The lack of vibration allows for slow shutter speeds, so atmospheric shots in low lighting levels are easier than from an aeroplane. A balloon can fly much lower than a plane, and a helicopter, besides being expensive, causes a lot of disturbance with its downdraught when it is

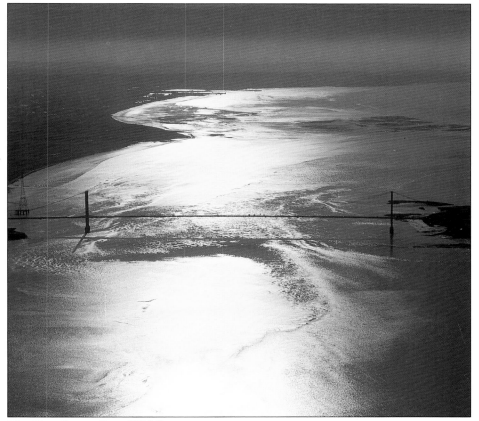

The River Severn from 3000 feet

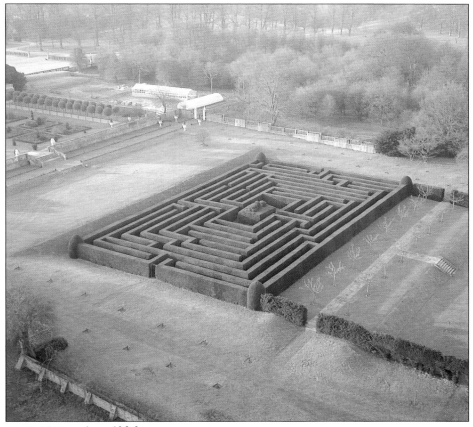

Hatfield Maze from 100 feet

hovering. The need to fly a balloon at dawn or at dusk is a positive advantage when it comes to landscape photography, as the sun's low position in the sky makes for more interesting shadows, which give the landscape more modelling and depth. The balloon's slow speed and the open design of its basket make it possible to compose photographs in a more leisurely way and with more attention to detail, than from an aeroplane rushing along at seventy miles per hour. It is like seeing the countryside from horseback rather than speeding along a motorway.

The unpredictability of a balloon flight is paradoxically another great advantage. As the balloon drifts irresistibly along, you find yourself floating over parts of the landscape that you had not planned to photograph but which cry out to have their picture taken. In October 1986 I set out for Chirk Castle and, for once, everything worked out. The weather was good, I had The National Trust's permission to fly from the castle lawns, and I had an experienced crew to help. I got up early, on a frosty morning, and there was hardly a breath of wind as we inflated the balloon and floated over the castle. Ten minutes later I couldn't believe my luck when the wind took me towards the one subject, apart from the castle, which I wanted to photograph in that part of the world.

This was the valley which Telford spanned with a magnificent aqueduct for the Shropshire Union Canal and where a later generation built a railway viaduct. Both structures run side by side, reflecting the changes in transport systems during the nineteenth century. My luck didn't stop there: the valley was suffused with shafts of light as the sun's rays lit up the early morning mist. This was a perfect example of serendipity, "the faculty of making happy and unexpected discoveries by accident", which exactly describes the unique character of a balloon flight and which provided me with many of the subjects for this book.

I have had a lot of difficulty getting photographs of Roman subjects. The importance of the Roman colonization in the history of the landscape is undeniable but there are very few sites that are photogenic – at least within the limitations of ballooning. Roman towns such as *Londinium* have grown out of all recognition into modern cities. The enduring success of the Roman towns also means that a number of sites that would be interesting from the air – the theatre at *Verulamium* for instance – are too close to modern city centres (and international airports) to be photographed from a balloon. Views of Roman villas such as Chedworth in Gloucestershire or Fishbourne in Sussex may appeal to the archaeologist, but from the air you mostly see modern roofing materials.

The most impressive Roman remains in Britain are to be found on the northern frontier, at Hadrian's Wall. But this is very difficult ballooning

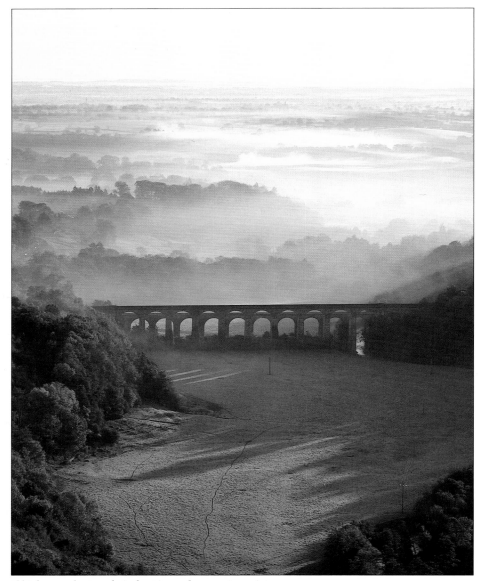

Chirk aqueduct and viaduct in early morning mist

territory. Its high, exposed position means that it has no shelter from the elements – and there are no natural windbreaks where a balloon can be launched. There is another serious problem: for a large part of its length, particularly at its most photogenic point near Housesteads, it is bordered on its northern side by the Forest of Kielder, home of the Rocket Testing Establishment at Spadeadam. I hate to think what a heat-seeking missile would do to a hot-air balloon.

Luckily the one Roman subject I did photograph gave me no such problems. The Cerne Giant in Dorset – a monument looked after by The National Trust – was probably carved during the Romano-British period, perhaps in an attempt to revive the fertility cult of Hercules, who is often represented with a club. I got this close-up photograph of him from my Sky Chariot – a small, one-man balloon designed to be as light as possible. Instead of a basket, there is a steel frame which makes a comfortable armchair, while the fuel tank serves as a seat. There is plenty of foam padding to protect me from the knocks and scrapes of fast landings, and a strong lap strap stops me from falling out of the chair. It is very exhilarating to look down on the countryside with my feet dangling free, although it is unnerving to fly higher than 2000 feet, when the ground seems alarmingly far away. The advantages of a Sky Chariot are that it can be carried on a car roof rack and it doesn't need a large crew. I have even devised a system for launching it completely solo. This involves using weights, tent pegs and special quick-release mechanisms, and I have had a number of flights which would have been impossible in a bigger balloon for want of crew. When I flew from Charlecote Park in Warwickshire, The National Trust Administrator was kind enough to come and fetch me, but one of the problems with solo launches is that I often don't have a retrieve to pick me up, so I need a way of getting back to my car. I get round this by carrying a lightweight folding bicycle as a form of insurance: if I bring the bike, I often get given a lift back. If I don't bother to carry it, I usually face a long walk. When I flew over the Cerne Giant I was lucky to be greeted on landing by a couple of children who talked their mother into driving me back. The bicycle stayed folded.

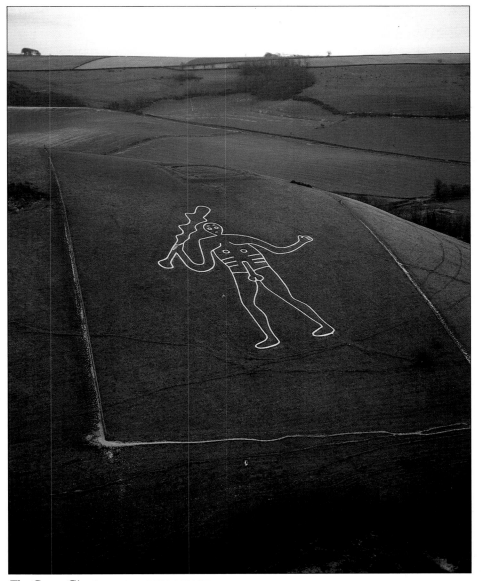

The Cerne Giant (THE NATIONAL TRUST)

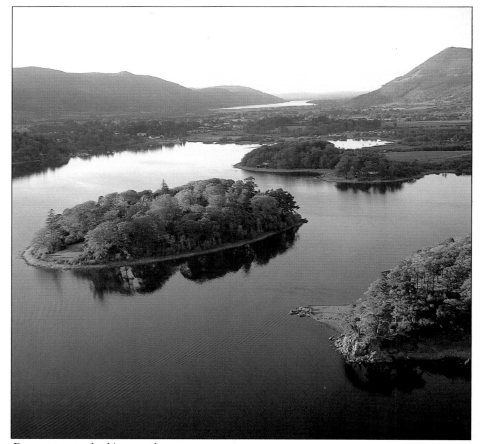

Derwentwater looking north (THE NATIONAL TRUST)

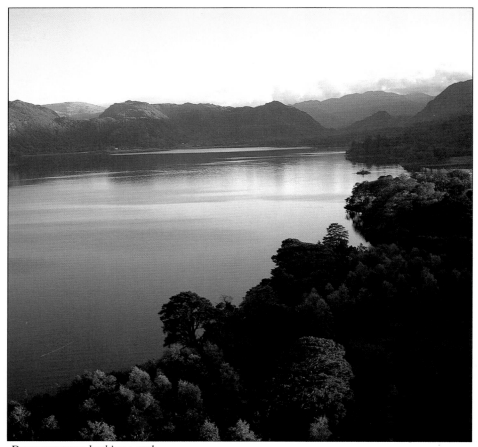

Derwentwater looking south

Over the last five years I have concentrated on putting together this collection of photographs, and I have come to realize that some types of subject are more rewarding to photograph from a balloon than others. Natural geological landforms, such as those in the Lake District, work well because of their intrinsic beauty and because a balloon gives a broad view. I was flying over Derwentwater, in Cumbria, when I took this series of shots towards the four points of the compass.

I had taken off from a field on the edge of Derwentwater. It was a perfect October evening, with the sun low in the west, casting long shadows. These four photographs were taken within a space of five minutes. The view to the north shows how Derwentwater is connected to Bassenthwaite Lake in the distance. For the view south, towards the mountains of the southern lakes, I was about a hundred feet above the trees, the perfect ballooning height.

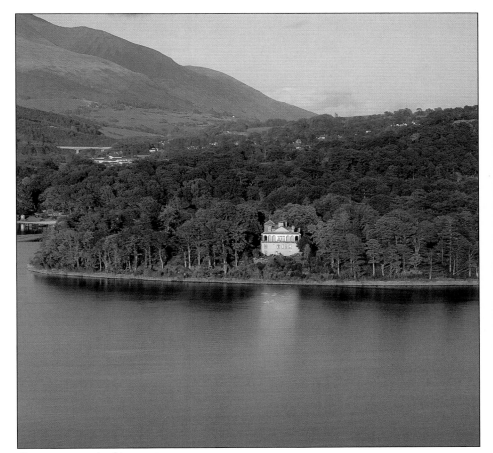

Derwentwater looking east

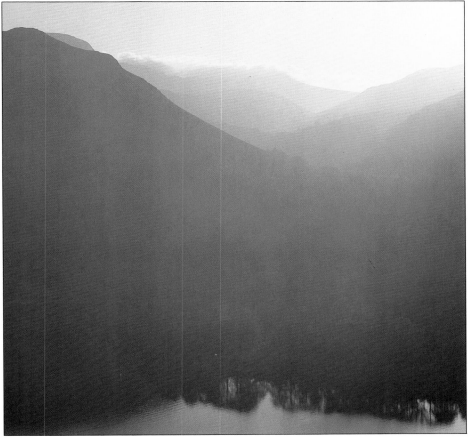

Derwentwater looking west

The first two views have a low, raking light falling across them, casting shadows which give a three-dimensional quality to the landscape, especially the mountainous backgrounds. For the view to the east there are no shadows, as the sun was directly behind me. The house on the island reflects down into the lake, while the granite slopes of Skiddaw rise in the background. The extra height above the water gives the reflections an added depth.

To complete the series I took the last shot, looking due west straight into the setting sun. I was struck by how different the light looks when the sky is backlit like this. In the distance cumulus clouds are forming, as a westerly airflow is pushed up by the mountains of the Lake District. I had hoped to fly again the next morning, but by then this westerly airstream had broken down the settled weather and the wind had picked up to speeds that made further flying impossible.

Prehistoric sites, particularly earthworks, are also successful subjects to photograph from a balloon because they were often planned on a large scale, and their remote positions give them an evocative and romantic setting. It is relatively simple to fly over Windmill Hill in Wiltshire, and Avebury has an excellent launch site in the grounds of the manor house built next to the stone circle.

But the perfect subject for a balloon photograph is a castle surrounded by open parkland and ringed with tall trees to provide shelter from whatever direction the wind is blowing. If the castle has a moat, so much the better, as the reflections of the castle in the water look especially good

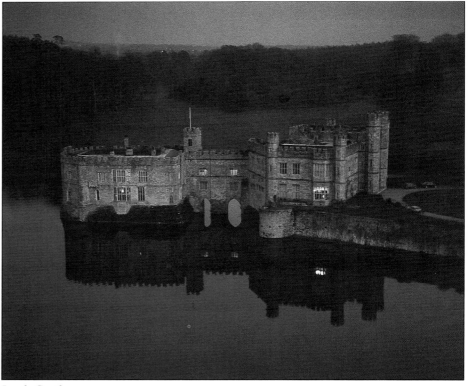

Leeds Castle

from balloon height. The castle should be away from the coast and clear of controlled airspace, and the owners should be obliging about the disturbance caused by the roar of balloon burners at dawn. Leeds Castle at Maidstone in Kent fits all these requirements and as a result I have flown more often from Leeds Castle than from anywhere else. But Bodiam Castle and Chirk Castle look pretty good from the air, as do the monastic ruins of Tintern and Rievaulx.

The list of requirements for a successful launch site can also be satisfied at a large number of historic houses and their parks and these form the next category of what I think of as "balloonogenic" sites. Although

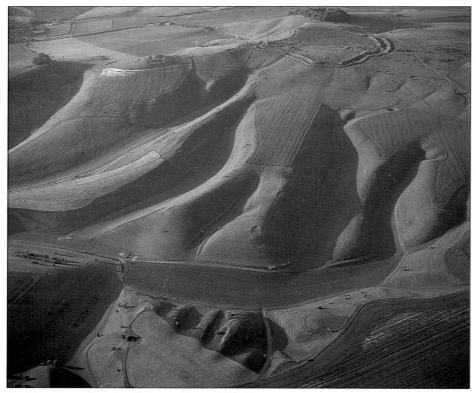

Prehistoric earthworks, Calstone Down, Wiltshire

Capability Brown knew nothing of ballooning (he died in the year of the first-ever flight – 1783) he had a genius for providing excellent launch sites. What we think of as the typical landscape garden is really the Capability Brown model: a handsome house set in the heart of its landscape, with the parkland apparently coming right up to the house (but in fact separated by a ha-ha), with a river meandering close by. The river was often dammed to produce a lake, the parkland broken up with clumps of trees to provide changing vistas, and the whole ensemble ringed with a belt of woodland.

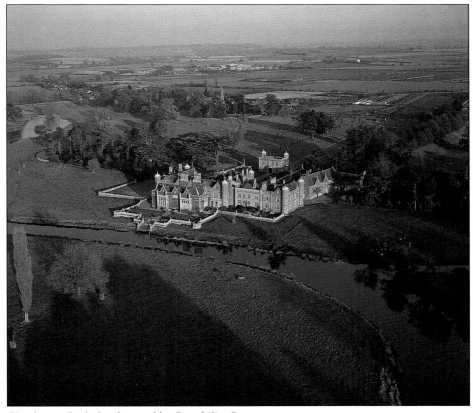

Charlecote Park, landscaped by Capability Brown (THE NATIONAL TRUST)

The photographs in this book concentrate on five main categories – natural landforms, prehistoric sites, unexpected features of the countryside, medieval ruins, houses and parks – because these are the aspects of our landscape that make ballooning worthwhile. I hope that the photographs give some idea of what it feels like to fly in a balloon.

The most charming description of a balloon flight that I have come across is in Lionel Brett's poem:

Lifting off at sunset, familiar backcloths
Drop away in an instant, the horizons wheel
And we swim above the tree-tops.
Look! There's the house, model-neat, ensconced,
Then gone. Green crests and spires slide past,
Between them wells of primal dusk and dread,
Then wood-smoke, children, a dog barks and scampers
And ponies plunge away. We rise, and are gone –
Take to the sky.

Time to go down, as the great dark quilt darkens and
Lights flash and flicker.
Voices come up from gardens, and a hare surprised in
Stubble doubles to and fro –
A maze of tracks to choose from.
Becalmed at last ten foot above the corn
(It's not the thing to land in standing crops)
We hover, creatures neither of earth nor air.

Geology

Looking down on the countryside from a balloon basket, you appreciate how much the appearance of the landscape is influenced by geology. The most interesting flying country is to be found in regions where the land is hilly or mountainous, such as Dartmoor or the Lake District. One of the thrills of ballooning is the way you can creep over the brow of a hill and drop down into the valley below, then soar over the same scenery at ten thousand feet. The sensation is rather like snorkeling in clear water: you can float on the surface or dive down to investigate something that catches your interest. Geological features, being on a large scale, are relatively easy subjects for ballooning photography: the exact position of the balloon is less critical than it is with smaller subjects, such as an individual building. This means that it is easier to find a suitable site to launch the balloon, without having to worry too much about getting the correct angle for the photograph. On the other hand, it is important to have clear visibility, without too much haze to obscure the horizon, which can be many miles away.

◄ THE LONG MYND

The Long Mynd in Shropshire is made up of rocks which are too old to contain any fossils – they are older than the first organic life on this planet. The Long Mynd rocks survive from the Pre-cambrian era. They were formed some 600 million years ago in a period dominated by volcanoes which built up above the surface of a shallow sea. These volcanoes spewed out vast quantities of lava which rained down over a wide area as layers of red-hot ash. In this volcanic terrain, a steep-sided valley accumulated huge amounts of silt and sand; these sediments were later folded by movements deep in the Earth's crust to form a rugged mountain area. In the centre of the Long Mynd is a U-shaped glacial valley of much more recent formation – a classic example of an Ice Age valley carved out of the landscape during the last two million years by the action of ice and frost. The debris which collected in the bottom of the valley is often fertile soil; here, its appearance has been changed by agriculture.

THE NATIONAL TRUST

THE LONG MYND ►

I have been unable to identify the circular and oval marks on the ground in this photograph of the Long Mynd: the Ordnance Survey map shows no prehistoric remains in this area. The surface, seen here under a light morning frost, is characteristic of eroded land older than the Ice Age. It would have acquired its polished appearance over a very long span of time during the Tertiary Period.

THE NATIONAL TRUST

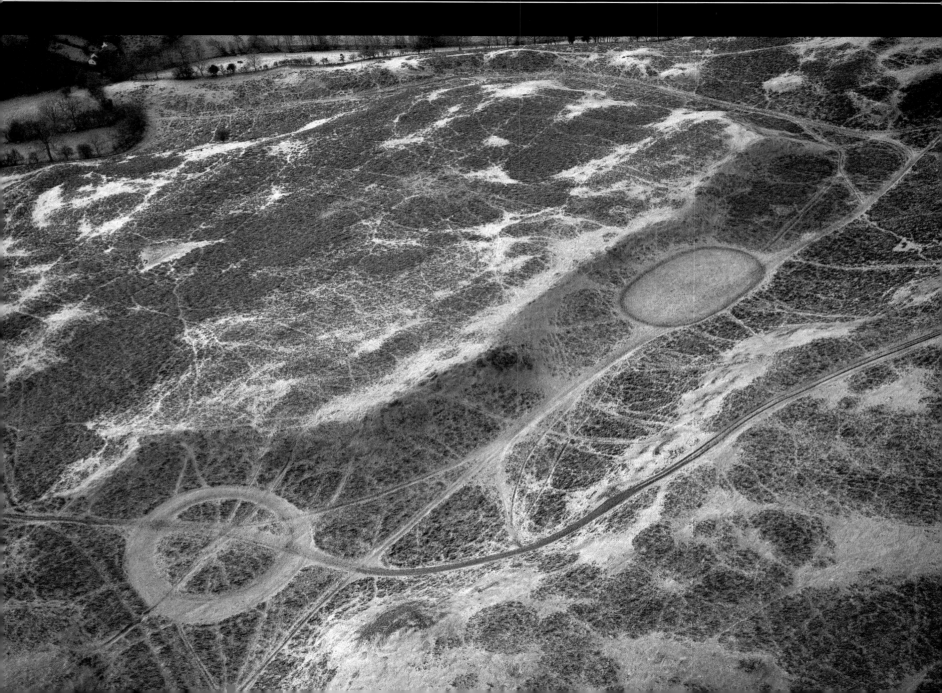

WENLOCK EDGE

The distinctive ridge of Wenlock Edge rises above Shropshire Plain. This area has been called "the geologist's playground", as the rocks here abound in very early fossils. They are later than the Pre-cambrian, or pre-fossil, rocks of the nearby Long Mynd, but have the same outward appearance. This is due to the fact that their present aspect owes more to the relatively recent action of vast quantities of snow and ice known as glaciation, and to permafrost, or periglaciation, than to the age of the rocks themselves. Comparing the landscapes of the Long Mynd and Wenlock Edge, Dr Marjorie Sweeting commented, "Because the rocks are later doesn't mean to say that the landscape is later. They probably evolved together."

THE NATIONAL TRUST

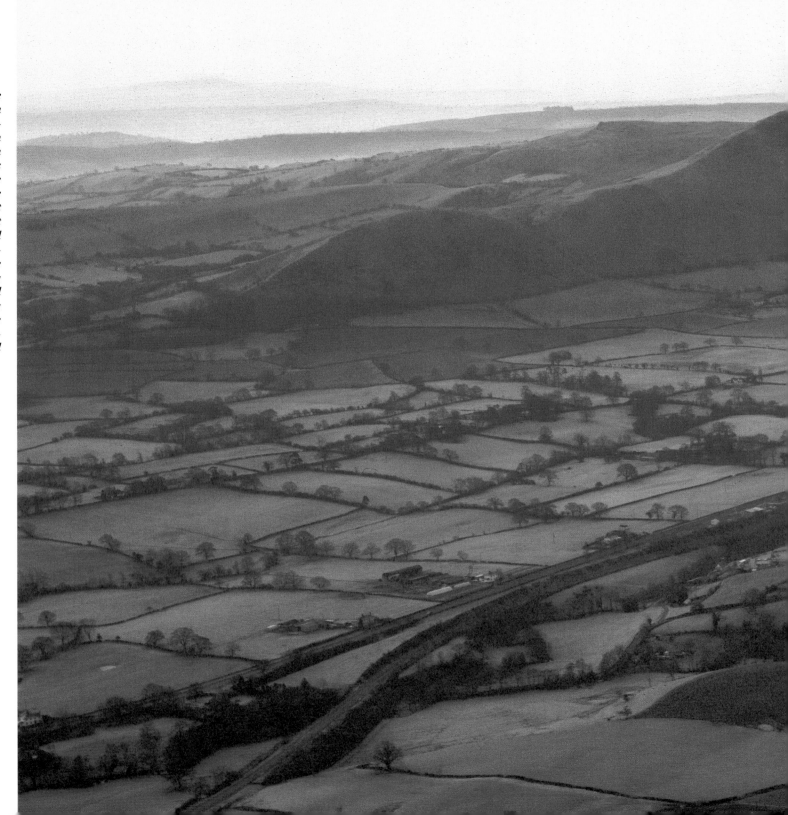

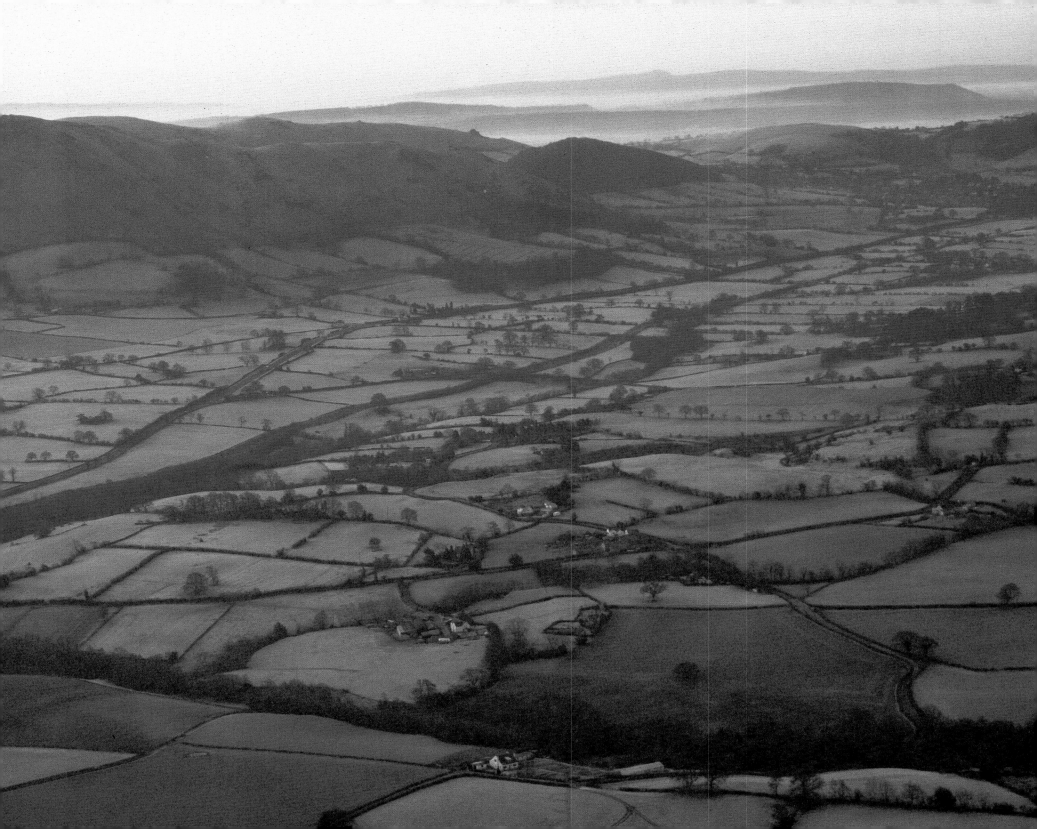

WHIN SILL

This rocky outcrop on the moors above Cragside is part of the Whin Sill which underlies much of Durham and Northumberland, breaking the surface in thin strips several miles long. The geological term "sill", used to describe such outcrops, comes from the Whin Sill itself. Whin Sill was formed by molten magma (the material that gushes from volcanoes as lava) being forced up under intense pressure, through existing rocks, to solidify on the surface as dolerite. The Romans built Hadrian's Wall along part of the Whin Sill, as the rugged strength of its rocks provided a natural barrier. Shortly after taking this photograph, I chose a nice empty field to land in. As soon as I was down, the field filled with Girl Guides who had their summer camp nearby. They were very excited by the arrival of the balloon and insisted on giving me a slap-up breakfast: bacon, eggs, sausages, fried bread and lashings of tea.

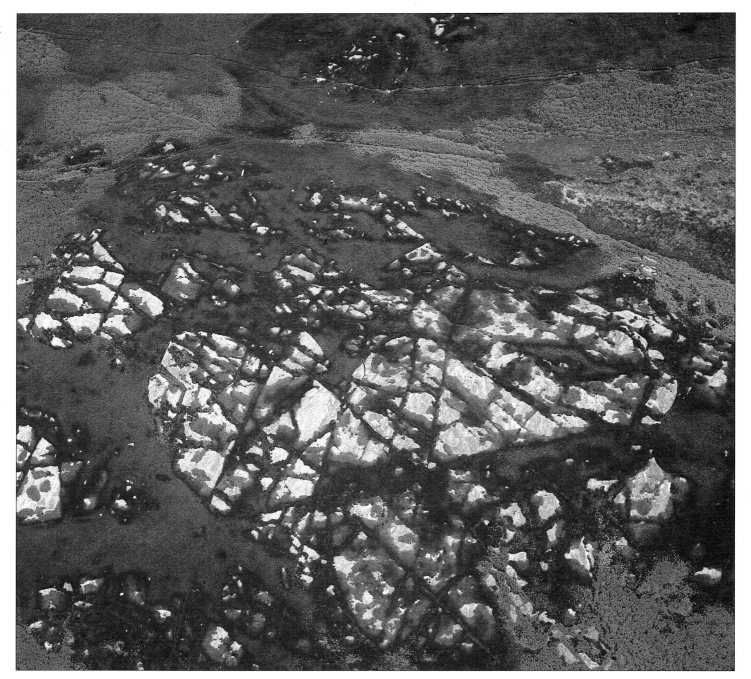

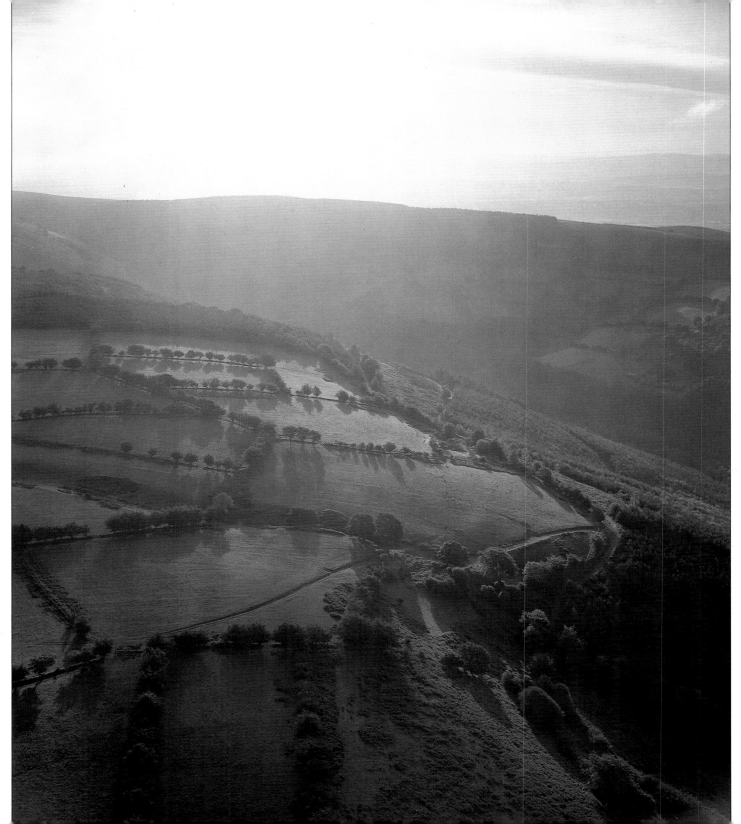

CWMBRAN

Cwmbran, a steep hilly area of south Wales, lies to the east of the coalfields of Ebbw Vale and the Rhondda Valley. The rocks of Cwmbran are composed of old red sandstone, a sedimentary deposit laid down during the Devonian Period, between 345 and 395 million years ago. Usually a dark red or reddish-brown, the sandstone has been used in many buildings in this region. Other areas of old red sandstone include the Brecon Beacons and the Black Mountains. This photograph was taken looking east, into the sun, on an early morning flight in summer. The Severn estuary lies beyond the hills on the horizon. As I didn't have enough fuel to cross the river safely, I put down abruptly in the next valley. It was another three years before I managed to fly the Severn.

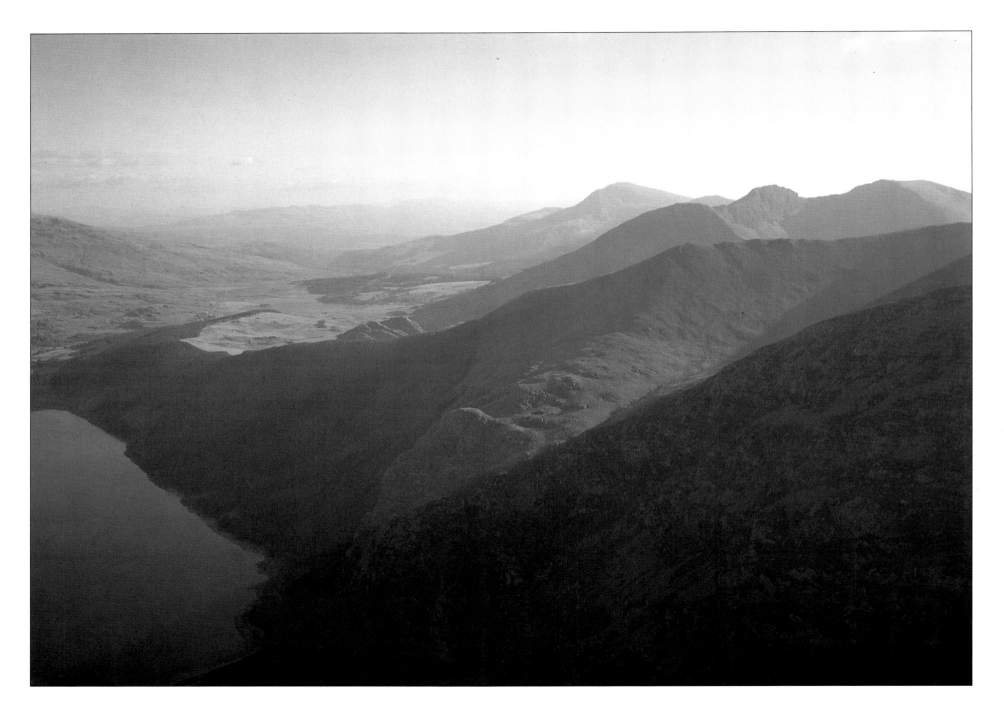

◄ SNOWDONIA

In Snowdonia a succession of peaks rises to roughly the same height, some 2000 feet above sea level. This so-called "2000-foot summit plane" extends from Snowdonia in north Wales to the Brecon Beacons in the south. The fact that it cuts across a wide variety of rocks suggests that the whole area was uplifted about 450 million years ago. Subsequent weathering and erosion planed off the mountain tops to a more or less uniform height. Mount Snowdon itself, being of more resistant rock, rises to 3500 feet. In the foreground is Llyn Cwellyn, a lake at the foot of the south-western slopes. This is connected by the River Afon Gwyrfa to Llyn-y-Gadair, a smaller lake, in the distance.
THE NATIONAL TRUST

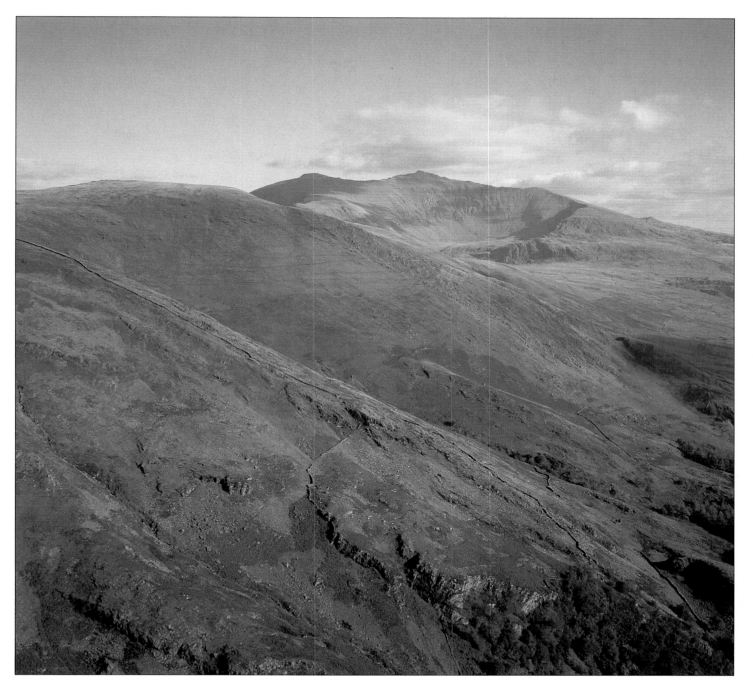

MOUNT SNOWDON ►

I was at 4000 feet and planning to fly over the top of Mount Snowdon when the wind dropped completely. Below, I saw an old slate quarry and what looked like a nice smooth track leading up to it. I made an abrupt landing and, having safely deflated the balloon, went to investigate. The track turned out to be a boulder-strewn bog. I had only one passenger with me and knew we could not carry the balloon between us. I was toying with the idea of an RAF helicopter rescue when, by good luck, a marathon runner out for a jog volunteered to help. Better still, he summoned his two strong sons. Two hours later, everything was packed and we were on our way. I still hope to fly over Mount Snowdon one day.

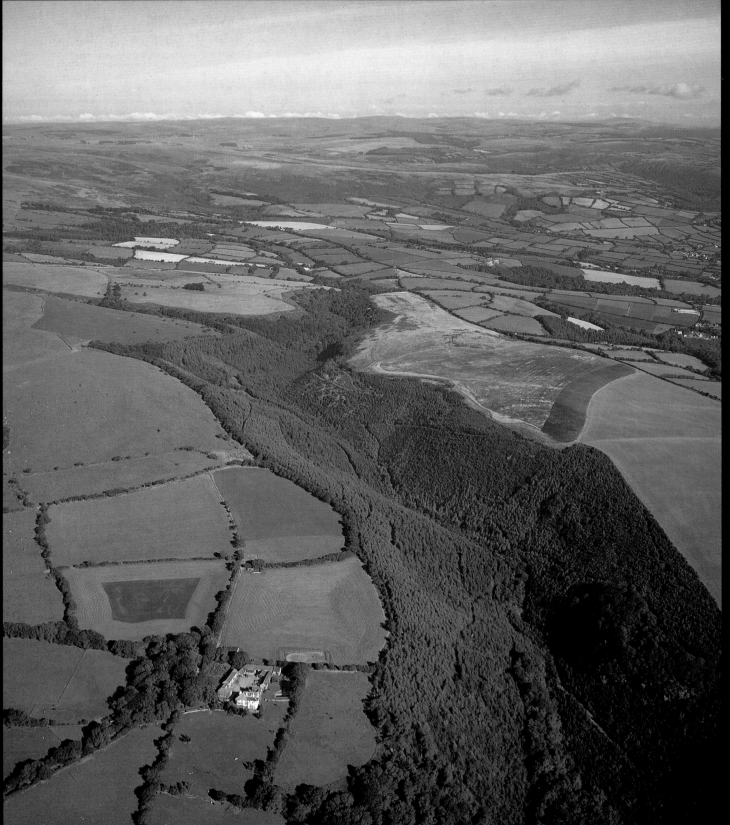

DARTMOOR

The great granite mass of Dartmoor, in Devon, was formed deep in the Earth some 300 million years ago. At that time the surface of this region was composed of sedimentary rocks. These rocks buckled in a mountain-building process, and molten volcanic magma rushed up to fill the spaces beneath the folds. The magma cooled and solidified to form granite. Eventually, particularly on high ground, erosion wore away the older surface rocks and exposed the granite. In its turn, the granite has been eroded by chemical decomposition, turning some of the granite into clay. Together with the high rainfall, this has led to parts of Dartmoor being waterlogged. During the last Ice Age permafrost, or periglacial activity, shattered the surface of the granite, accelerating the effects of weathering. The steep wooded valley on the southern side of the moor marks the course of an ancient river.

THE NATIONAL TRUST

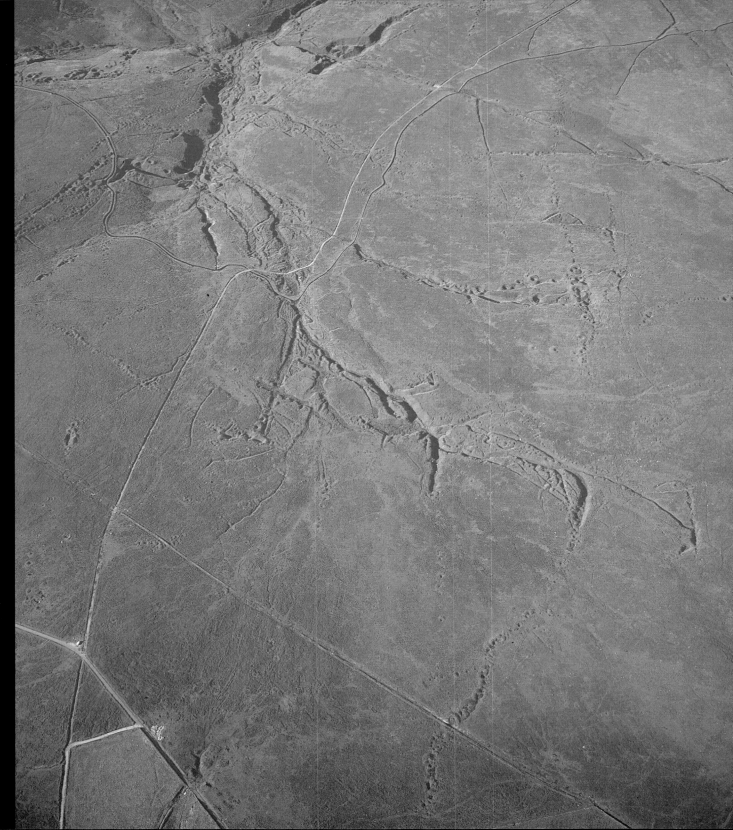

DARTMOOR

The bleak wilderness of Dartmoor looks very forbidding from 10,000 feet. The area to the south of the prison at Princetown is itself some 1000 feet above sea level and sufficiently uninviting to discourage prisoners from trying to escape. Too high and exposed to support any farming today, this area on the edge of Dartmoor has, nevertheless, numerous prehistoric sites. The branching pattern shown in this photograph is caused by a network of rivers and streams which rise here and flow on to fill the reservoir at Burrator.

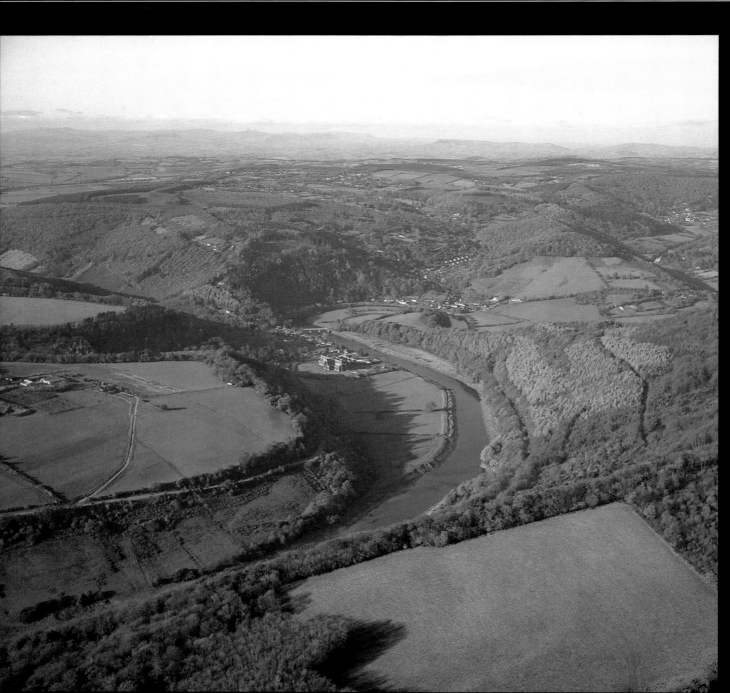

◄ THE RIVER WYE

At Tintern, the site of the famous ruined monastery, the River Wye loops round a bend almost as tight as a shepherd's crook. This is a classic example of an "incised meander". Millions of years ago, when the river first started to flow, its circuitous course lay on top of a flat plain not much above sea level. Since the formation of the river, the western side of the British Isles has experienced considerable "uplift", resulting in the surface of the land rising by several hundred feet. But the river, rather than being diverted, has gradually cut its way down through the uplifted rock, keeping its original meandering path. At Tintern, the usual processes of erosion have left the harder rocks on high ground and worn away the softer areas to produce a hilly landscape.

THE RIVER SEVERN ►

The Cambrian Mountains on the skyline provide a contrast to the valley of the River Severn as it wends its way south near Welshpool. The gently rounded hills in the middle distance owe their appearance to being over-ridden by ice during the last Ice Age. Today the Severn flows down to the Bristol Channel but originally it flowed north to the Dee and the Irish Sea. The ice, coming from the north, formed an insuperable barrier in that direction and the Severn was forced to find a new outlet to the south. I took this photograph on the maiden flight of my large balloon, G – BMKV.

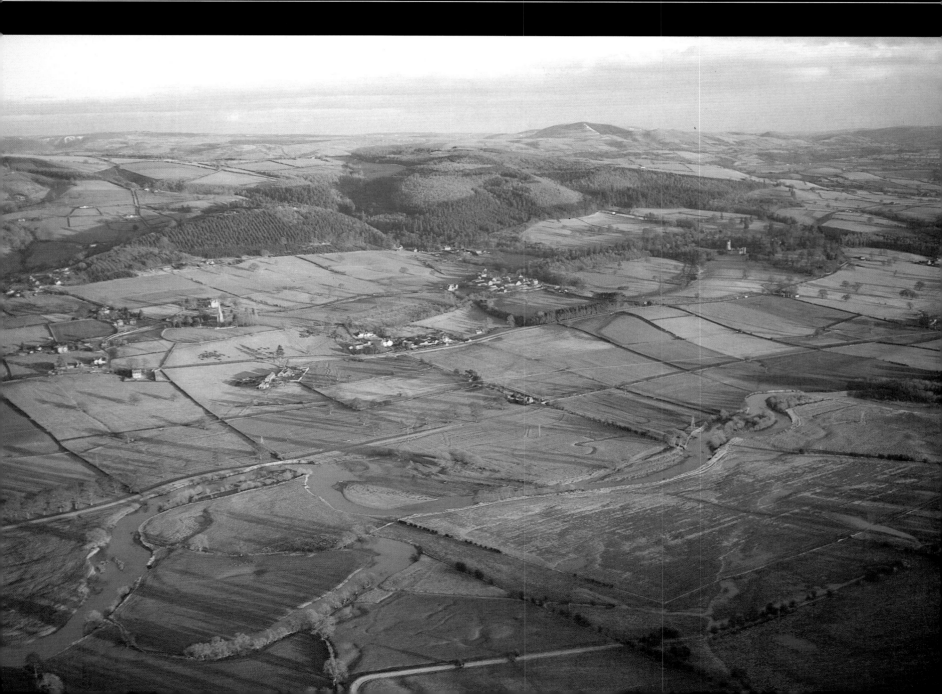

THE SEVERN ESTUARY

At low tide, the banks of the River Severn reveal a series of terraces in the mud. At high tide, the water usually reaches the boundary between the dark green vegetation and the silvery mud, and in the mudbanks can be seen the line where the mud is being eroded by the water. This line is itself made irregular and wavy as it is nibbled away by erratic drainage from the marsh-lands to the left. The area of dark green is periodically flooded by exception-ally high spring tides which have worn smooth the edge of the lighter green area. The area of lighter green was once in exactly the same situation as the dark green is now but, during a period of "uplift", it was raised above the usual high-water mark. Whereas the dark green area is now riddled with drainage channels, the light green has only a few, but the remnants of former drainage channels can be seen in its wavy outline. At the bottom of the photograph is the channel cut by the Severn's tributary, the delightfully named Old Splott Rhine.

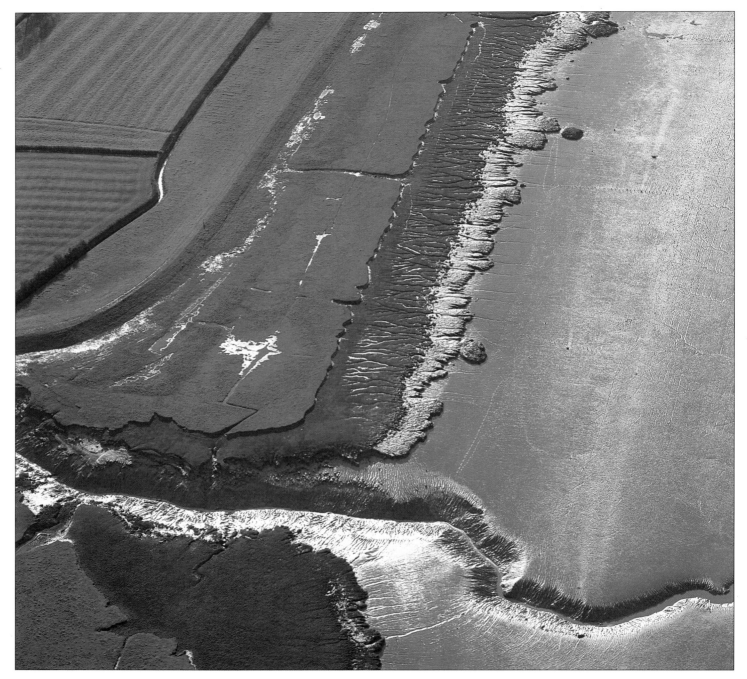

SKIDDAW

The skyline to the north-east of Keswick, in Cumbria, is dominated by the granite mass of Skiddaw. The granite is thought to have been in existence by the Ordovician Period, some 450 million years ago, when this part of the Lake District was undergoing the process of mountain-building. Despite enormous changes since then, the granite still makes a bleak contrast with the surrounding countryside – compare the rich green of the hill in the foreground of this photograph. The present appearance of the Lake District is mainly the result of glaciation, which scooped out valleys and rounded off the tops of the hills during the last Ice Age – a mere two million years ago.

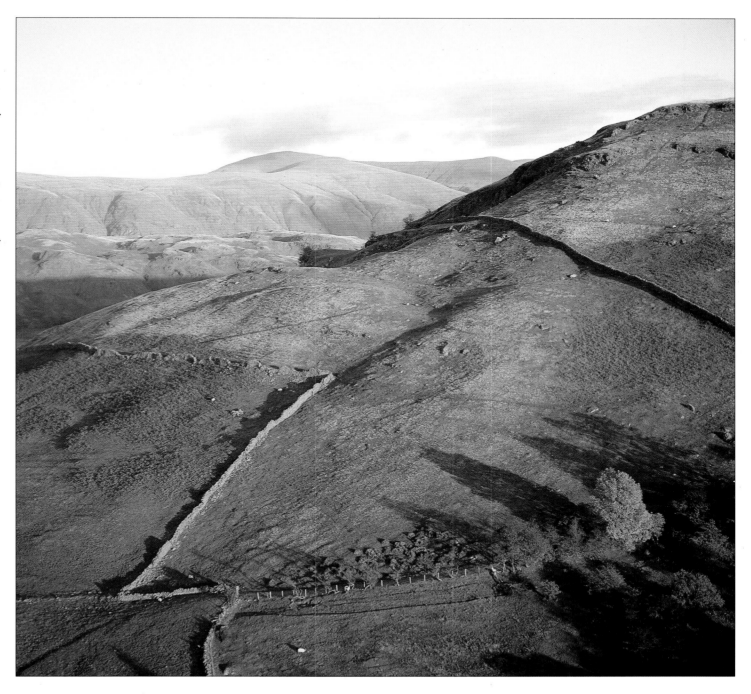

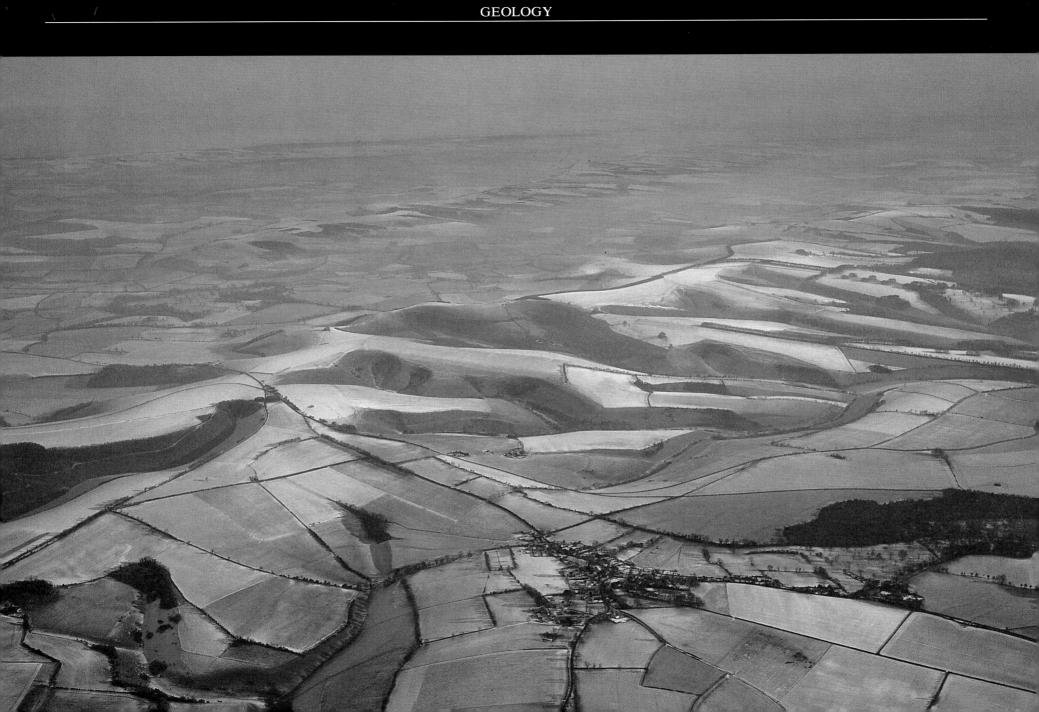

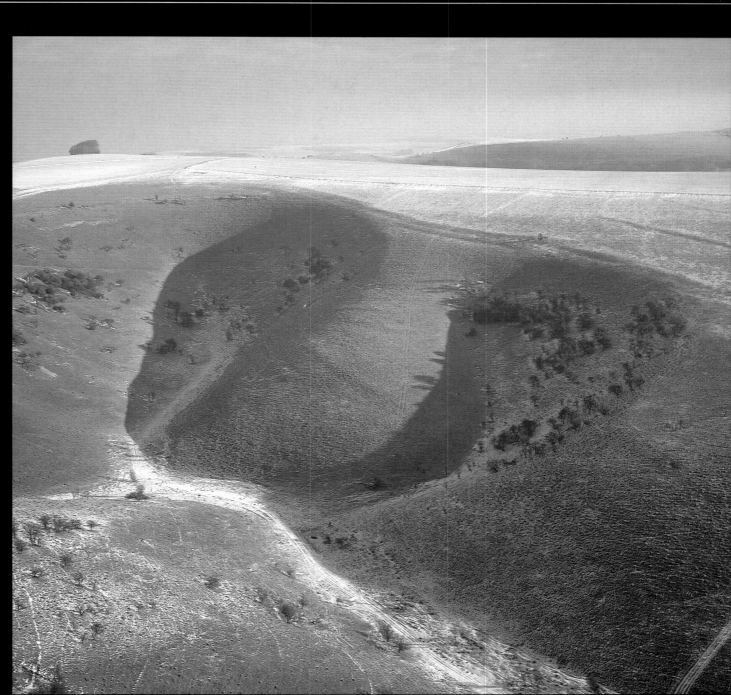

◄ CRANBORNE CHASE

On the border between Wiltshire and Dorset, the spectacular landscape of Cranborne Chase looks at its best with a light sprinkling of snow. This is wonderful country for ballooning, whether drifting along the valleys or sailing serenely at 6000 feet, as when this photograph was taken. Cranborne Chase is a landscape of chalk, part of the belt of chalk that continues as far as Brighton to form the South Downs. Chalk is a white, soft limestone made from the hard parts of coccoliths – *very simple, minute floating organisms which abounded some 100 million years ago. But soft chalk proved no match for the colossal power of glaciers, which carved the land into the patterns of rounded hills and steep-sided valleys that we see today. The double scoop of Quarry Bottom can be seen in the centre of the photograph.*
THE NATIONAL TRUST

QUARRY BOTTOM ►

Quarry Bottom lies just south of Win Green Hill, the highest point in Cranborne Chase. At 911 feet, crowned with a clump of beech trees, Win Green Hill offers magnificent- views in all directions. Quarry Bottom is a typical example of periglacial action, or permafrost, scooping out chalk. This low-level photograph was taken at about 700 feet. One of the thrills of hot-air ballooning is to drift down into a valley and see it close up, and then to climb several thousand feet and see it as part of the whole landscape.

SOUTH AND NORTH DOWNS

Although separated by some fifty miles, the South Downs of Sussex (far left) and the North Downs of Kent (left) were once connected as a continuous area of chalk which extended to Salisbury Plain in the west, the Isle of Wight in the south, the Berkshire Downs in the north and on into East Anglia in the north-east. At its thickest, this chalkland is 1500 feet deep. The deposit of chalk was laid down during the Cretaceous Period, which ended about sixty-five million years ago. Since then the central section has been stripped away by erosion, leaving the Kentish Weald between the North and South Downs. Both sets of downs are characterized by the escarpments which face each other across the Weald. The view of the North Downs was taken just north of Maidstone, on a flight from Leeds Castle. The view of the South Downs was taken to the south of Petworth.

Prehistory

The earliest traces of human life in Britain are about a quarter of a million years old, but it is only in the last seven or eight thousand years that human activity has had any lasting effect on the appearance of the landscape. Before the arrival of Stone Age farmers, much of Britain was covered by primeval forest. The clearance of these forests, especially on the chalk downs of southern Britain, was itself a major contribution to our landscape. Still more impressive, though, are the earthworks of the prehistoric period, from the stone circles of Stonehenge and Avebury to the colossal hillfort of Maiden Castle. Every time I have flown over the chalk downs I have seen remains of these structures. Many of these earthworks are so large that their three-dimensional quality, their scale and overall design can best be appreciated from the air – a balloon, with its leisurely pace, is a good platform. The work involved in shifting the huge amounts of earth needed to construct the banks and ditches at Maiden Castle, when the most sophisticated tool available was the shoulder blade of an ox, leaves the imagination reeling.

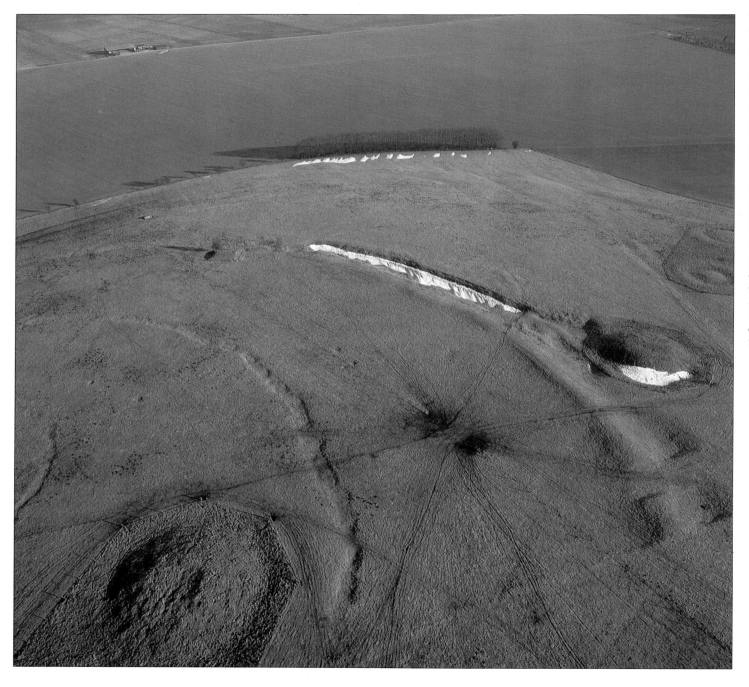

WINDMILL HILL

Traces of snow picked out some of the ancient earthworks as I flew over Windmill Hill in Wiltshire on a winter's morning. With three roughly concentric rings of ditches, Windmill Hill is the largest Neolithic camp in England. The ditches of such camps had many gaps, or causeways, and these sites are therefore known as causewayed camps. Windmill Hill has been the subject of much research, and excavations have revealed more than 1300 items of pottery, along with wood-ash and objects made from flint and stone. Apparently the camp was used for ceremonies which included throwing these objects into the ditches and burying them. Radio-carbon dating suggests that the camp was in use about 3350 BC. The round burial barrows are Bronze Age. The star-shaped pattern is probably caused by motor cycle scramblers.
THE NATIONAL TRUST

WINKLEBURY

The hillfort at Winklebury was built on the Downs to the north of Cranborne Chase in Wiltshire. Within a radius of a few miles can be found the Stone Age Dorset Cursus, numerous Bronze Age burial mounds and the Iron Age hill-forts of Hod Hill and Winklebury. The later stages of the Bronze Age had seen a dramatic increase in population as Celtic immigrants, skilled in warfare and the manufacture of weapons, arrived in large numbers. Rivalry between different tribes led to ferocious fighting and Iron Age forts were built throughout the country, especially in the downlands of southern England. This is ideal ballooning country and the numerous hillforts are an added attraction for the aerial photographer. Winklebury was apparently built in three stages, each unfinished. The area we see here was mostly constructed around 250 BC, but in 50 BC the fort was reduced to the smaller area higher up the slope (top right).

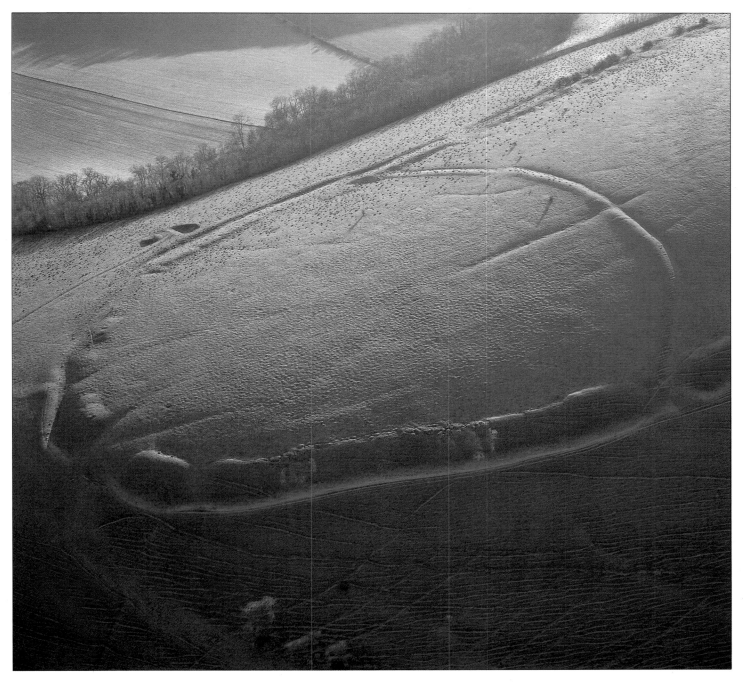

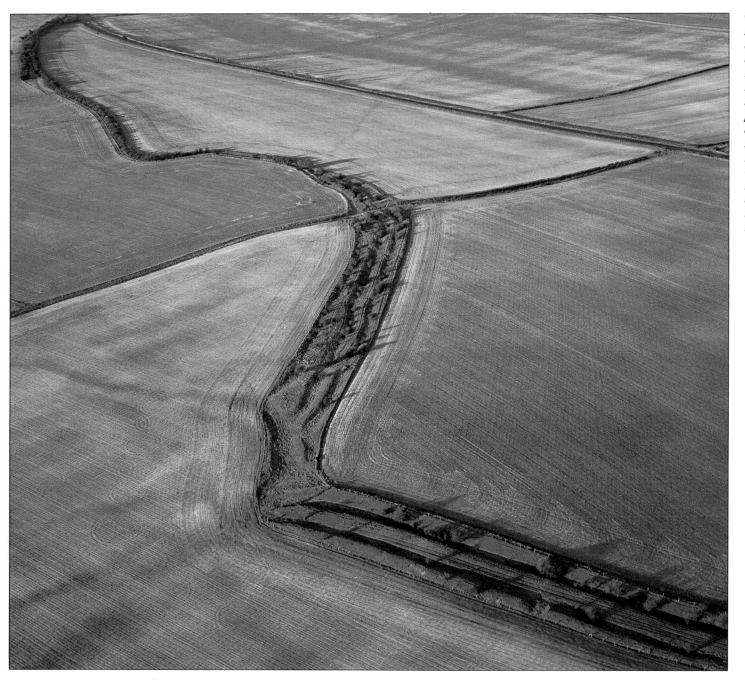

GUSSAGE HILL EARTHWORKS

At Gussage Hill in Dorset there was an extensive Iron Age settlement, with an enclosure which probably housed a large farm, complete with huts and barns. The well-preserved earthworks shown in these two photographs are part of this complex, and the massive double banks and ditches indicate the scale and importance of the Gussage Hill settlement. I was flying from Cranborne, about three miles to the north-east when I came across these earthworks. The overall view (left) was taken at about 1000 feet; for the close-up (right) I dropped down to 150 feet.

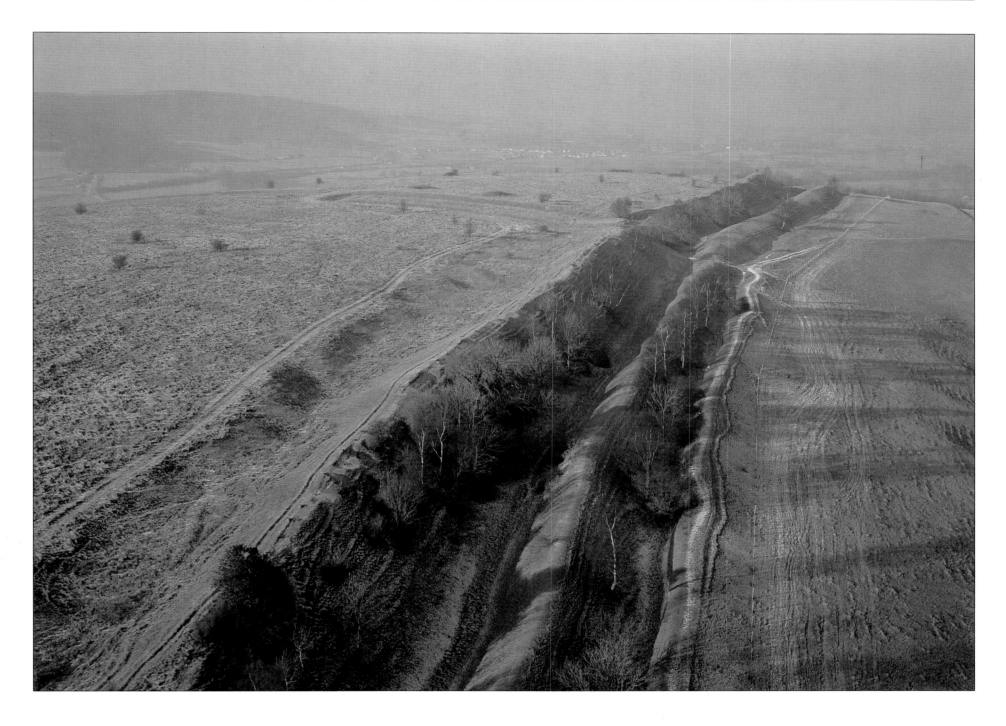

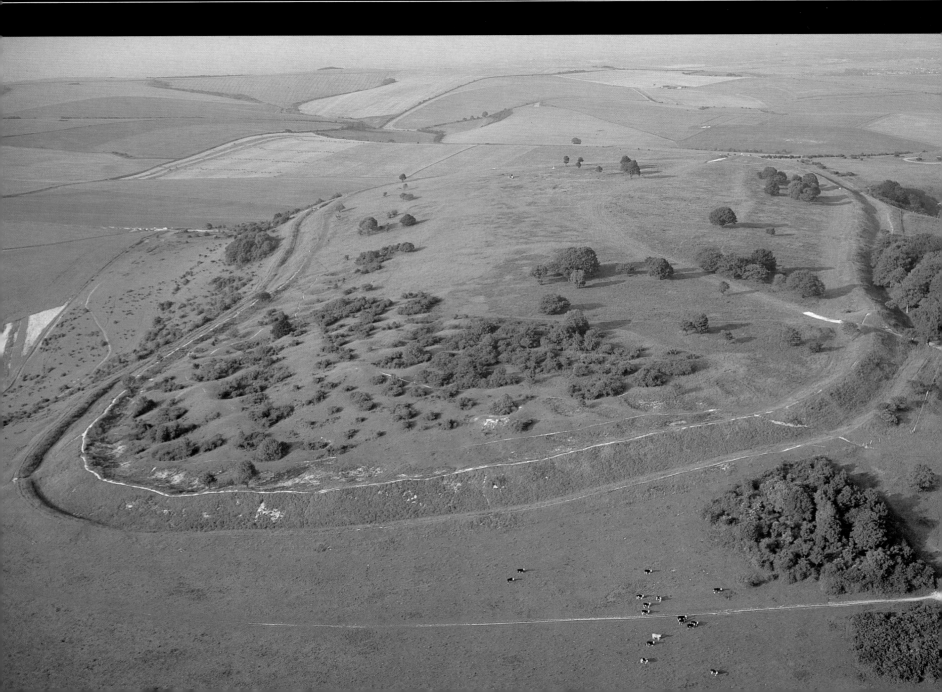

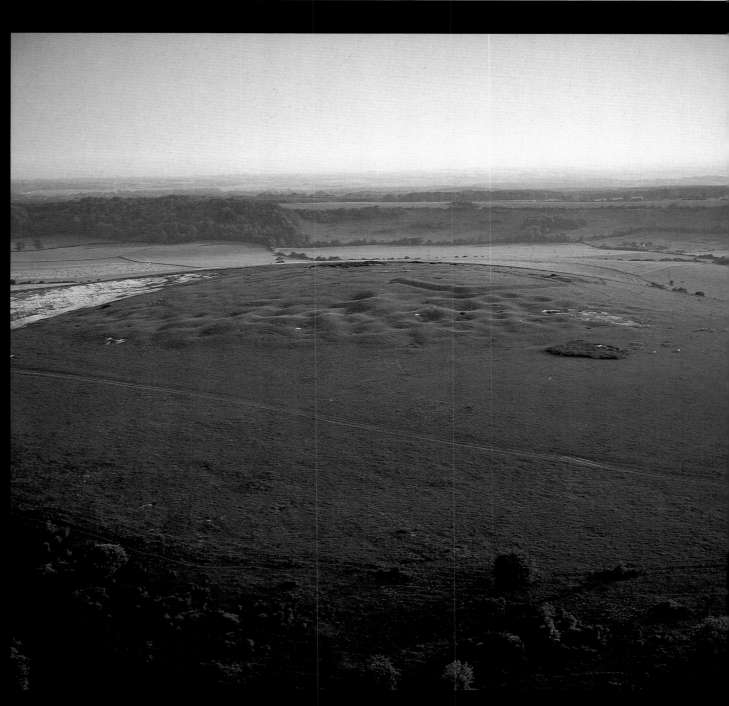

◄ CISSBURY RING

The hillfort at Cissbury, Sussex, is Iron Age, some 3000 years later than the Neolithic flint mines, which show up as pock-marks on the western side. Dating to around 350 BC, the hillfort encloses twenty-six hectares and is built on a site which slopes up to the east, giving commanding views towards Shoreham and Brighton. It is protected by a double bank; the stronger inner bank, reinforced with wooden stakes and a rampart, reached a height of fifteen feet. Between the two banks is a ditch which went down about seven feet. To the south and east were simple entrances. Shadowy marks on the grass at the top of the fort show the position of "lynchets" or field systems, dating from the Roman period when the fort fell into disuse and the interior was ploughed up.

THE NATIONAL TRUST

FLINT MINES ►

These strange pock-marks on the Sussex Downs indicate Neolithic flint mines. The dimples were formed as the mines collapsed. There are more than 200 flint mines here at Cissbury and they go down through six layers of flint and chalk to a depth of about forty feet. At the bottom, up to eight shafts radiate outwards. The mines were dug with picks made from deer antlers; an antler pick taken from one shaft has been dated to about 3600 BC. In one of the mines, a woman's skeleton was found; she had apparently fallen in head-first. Excavations have also uncovered a young man's body buried in a grave made from blocks of chalk.

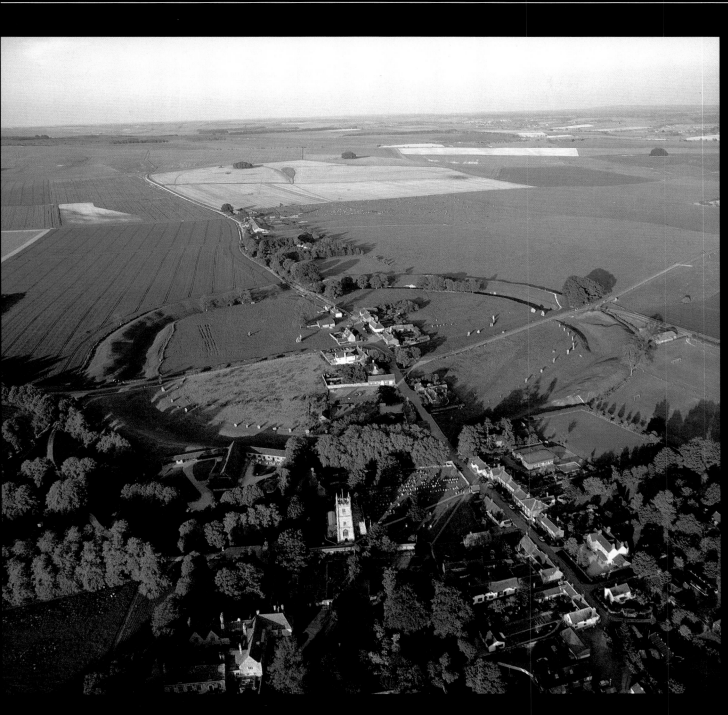

STONE CIRCLE, AVEBURY

The site of Avebury "does as much exceed in greatness the so renowned Stonehenge, as a Cathedral does a parish Church", wrote John Aubrey in the 1660s. The circle, with its massive bank and ditch, is more than half a mile in circumference and was constructed in the Neolithic period. There are entrances to the circle at the four points of the compass. Recently discovered drawings suggest that Avebury may originally have been on an even more colossal scale, with avenues of stones stretching out beyond the four entrances. If this is true, then Avebury would have been at the centre of a gigantic cross. Many archaeologists consider Avebury the single most important prehistoric site in western Europe, despite the fact that the stones, over the centuries, have been much damaged as well as plundered for building materials. I fervently hope that the new owner of the Elizabethan manor house, seen in the bottom of this photograph, is frustrated in his plans to create a theme-park, which would desecrate this ancient, mysterious monument.

THE NATIONAL TRUST

BADBURY RINGS

King Arthur's victory over the Saxons at the legendary Battle of Badon was possibly fought here at Badbury Rings, in Dorset, around AD 500. This Iron Age hillfort has three concentric rings of banks and ditches, surrounding a miniature wood. The outermost bank is the weakest, and there are entrances to the west and east. The western entrance, on the left, has the added defence of a "barbican" or enclosure, formed by the central bank breaking forward. The defences were destroyed by the Romans, who cut the line running through the barbican, probably to demilitarize the fort when they captured Badbury in AD 44. On the northern, or far side, the Ackling Dyke – the Roman road from Dorchester to London – is clearly visible; at one point it clips the outer ring. I was very lucky to see the hillfort at such close range. I was flying from nearby Kingston Lacy one summer evening when a change in wind direction carried me directly over Badbury Rings.

THE NATIONAL TRUST

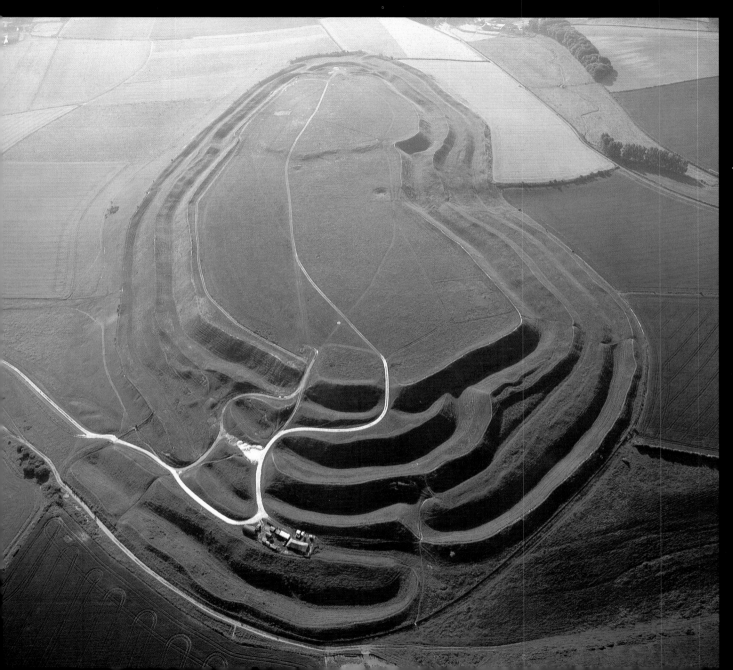

MAIDEN CASTLE

The most impressive of all the Iron Age hillforts in Britain, Maiden Castle in Dorset has a long and complicated history. There was an earlier Stone Age causewayed camp on this site, but most of what we see today was built during the Iron Age. By about 150 BC the defensive ditches and ramparts were completed and the ramparts were reinforced with a stone wall, built with materials quarried inside the fort. In the foreground can be seen the convoluted entrance, designed to prevent attackers from rushing the fort and built by about 75 BC. But all these defences, including an arsenal of some 50,000 sling stones collected from Chesil Beach about eight miles away, were no match for the might of the Roman army. In AD 44 the Second Legion, led by Vespasian, stormed the east gate, which can be seen at the top of the photograph, and overran the fort. It is only in an aerial view like this that the scale and design of Maiden Castle can be appreciated. The earthworks were massive: the outer ditch ran for over a mile and a half, and from the top of the rampart to the bottom of the ditch was over seventy feet in places.

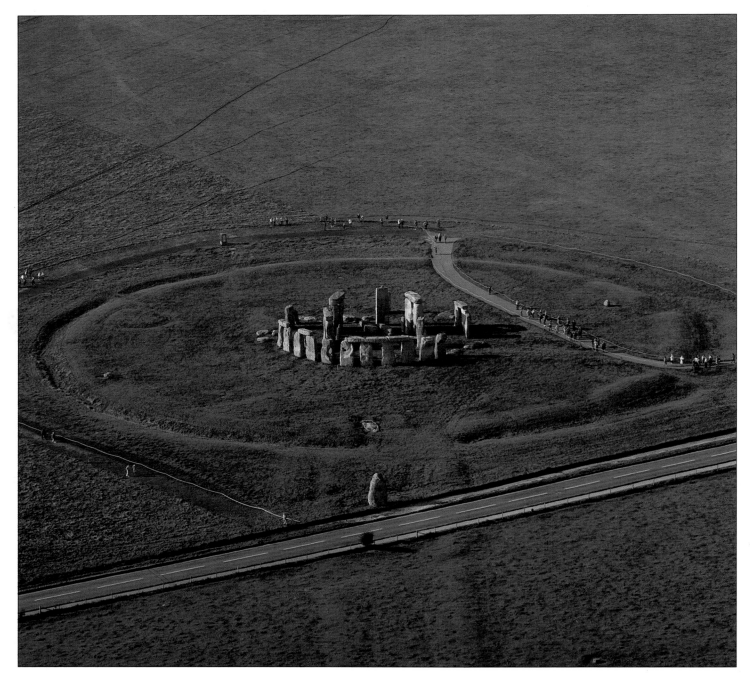

◄ STONEHENGE
Stonehenge, the most famous prehistoric monument in Britain, is surprisingly small. What remains is only the last phase in its history. The site was used in Neolithic times, but the first stone circles date from the Beaker Folk, who lived here in about 2100 BC. About 400 years later, around 1700 BC, the people of the Wessex Culture built the temple whose ruins we see in Wiltshire today. The stone circles stood inside a large circular bank and ditch, with an avenue to the north-east. These show up well from the air, looking like a saucepan with a handle. The "heel" stone, by the side of the modern road, marks the former gateway from the avenue to the temple. This is very difficult ballooning country, as Stonehenge is on the edge of Salisbury Plain, the largest military training ground in England.

WHITE HORSE, UFFINGTON ►
Every few years there used to be a horse-cleaning party on Uffington in Berkshire, when the locals also indulged in festivities such as wrestling, horse racing and rolling cheeses down the hill. The White Horse of Uffington probably dates from the late Iron Age; the stylized outline of the horse is similar to metalwork of the period. The area has inspired a number of legends, among them that St George slew the dragon on the nearby flat-topped hill and that the bare patch of chalk marks the spot where the dragon's blood was spilt.
THE NATIONAL TRUST

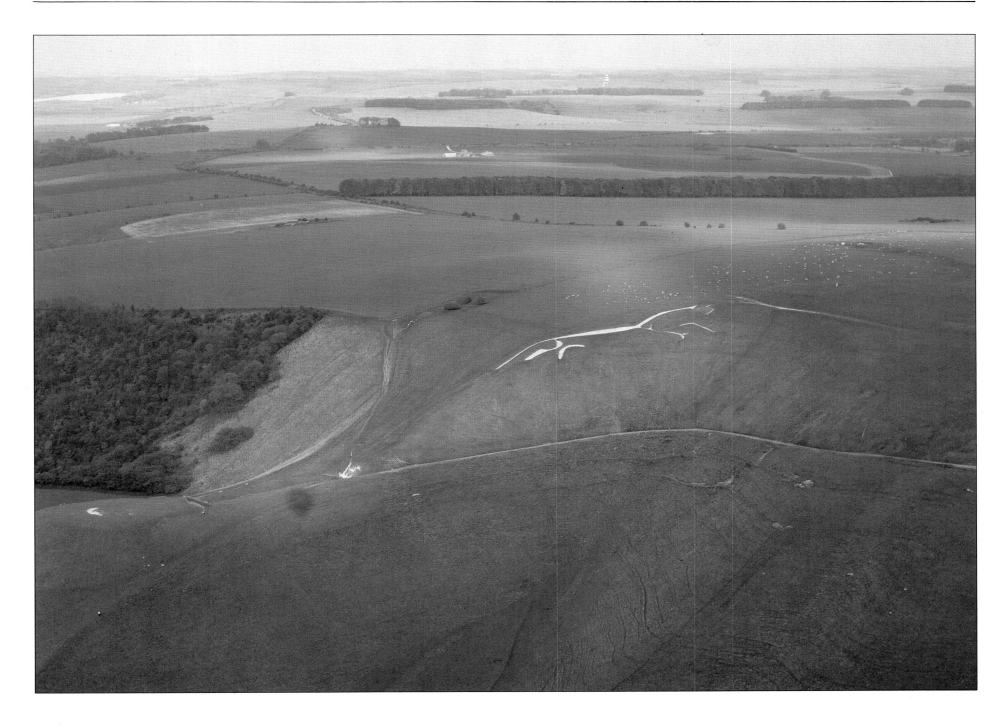

Serendipity

The photographs in this section were taken because I happened to fly over something that caught my interest, rather than as the result of careful planning. One of the charms of ballooning is that you can't control everything down to the last detail: once you have decided where to take off and how high to fly, the rest is up to the vagaries of the winds. You cannot predict your flight path, nor where you will land. The other great attraction of ballooning is the slow speed, usually between five and ten miles per hour, which gives you plenty of time to notice, and photograph, unexpected details of the landscape. I took off from Hailes Abbey in Gloucestershire with the intention of photographing the monastic ruins, but I had not expected to see a textbook example of medieval ridge and furrow ploughing patterns two fields away. Even more fortuitous was the last flight I made for this book. I had taken off from the ruins of Tintern Abbey, when the wind took me out across the River Severn with a breathtaking view of the great suspension bridge, which gave me the photograph included in the Introduction.

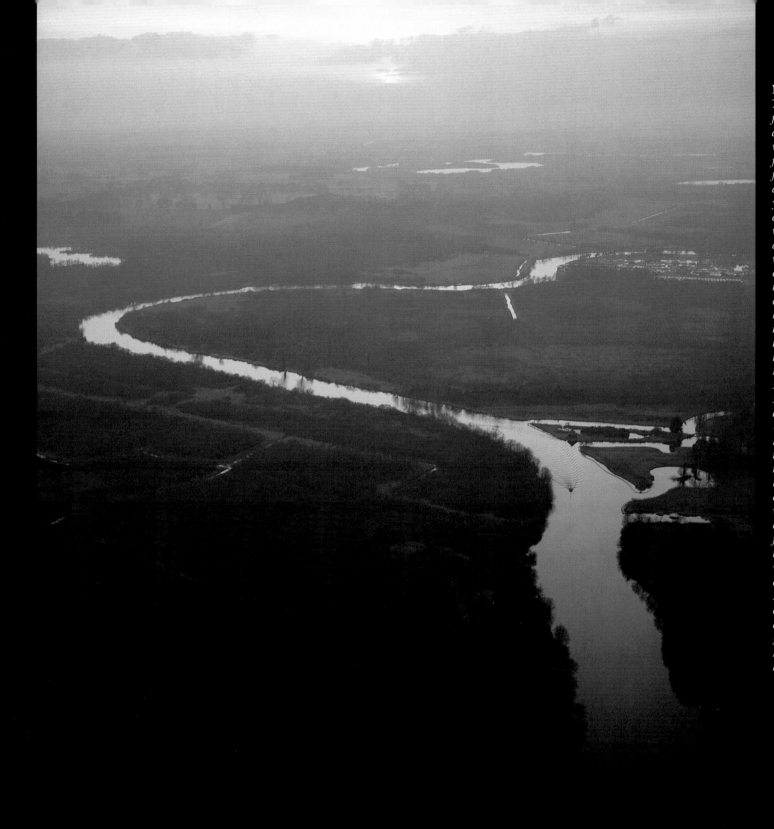

NORFOLK BROADS

The Norfolk Broads show up clearly from the air, but at ground level they are mysterious and secretive. The lush vegetation around their edges and the flat East Anglian terrain make it difficult to see the water unless you are actually on it. Sometimes the only clue you get is when a sailing boat glides disconcertingly across the middle of what appears to be a solid field. This is a unique landscape, famous for its woods and meadows, reed beds and rivers, windmills and church towers, and not least the abundant wildlife, especially the water birds which congregate here. The Broads owe their existence to medieval peat-diggers, who removed many millions of cubic feet of this valuable fuel from the peat bogs around Norwich. The pits they left behind were subsequently flooded as land levels sank relative to the sea, probably around the turn of the 14th century. Until recently, the reed beds of the Broads provided a plentiful supply of thatch for the roofs of East Anglian cottages. Today the survival of the Broads is in jeopardy. As agricultural chemicals run off the land, they pollute the water, endangering the flora and fauna of the region. A further threat comes from their popularity with holiday makers. In the summer months the wash from numerous motor launches churns up the banks and the consequent erosion leads to the silting up of the waterways. Ranworth Broad, the expanse of water seen in the photograph on the right, is in the care of the Norfolk Naturalist Trust and escapes most of the river traffic.

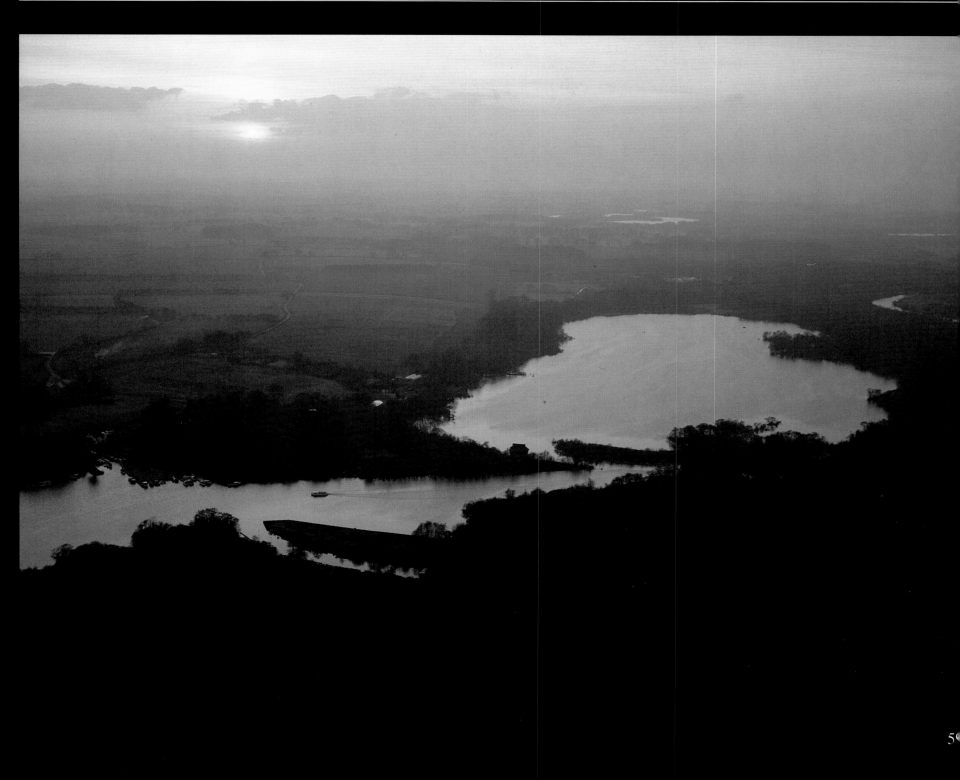

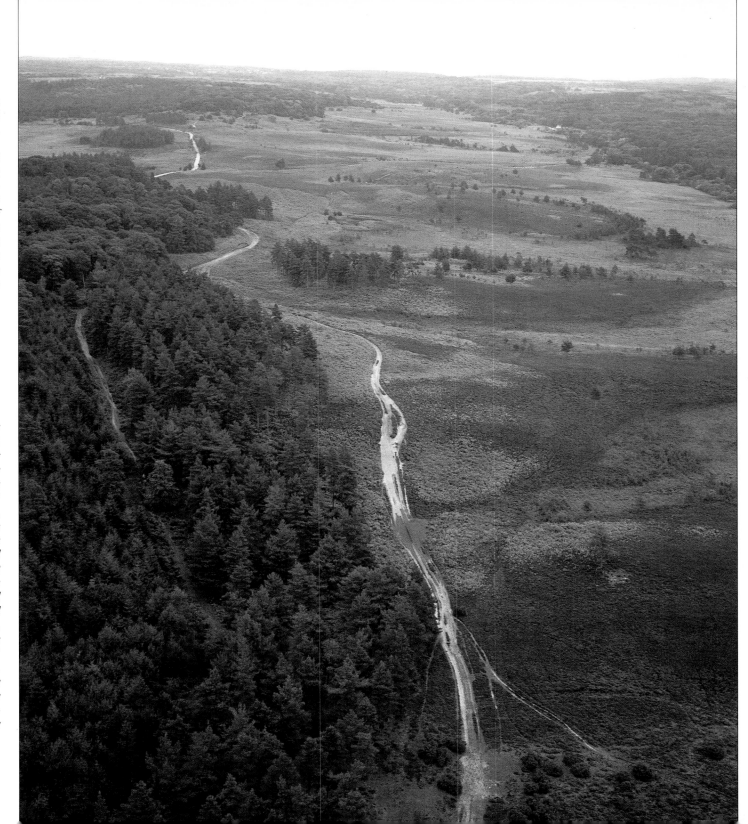

◀ RIDGE AND FURROW

Traces of medieval ploughing in an open field system survive as ridge and furrow marks in many parts of England. Near Winchcombe, in Gloucestershire, the open field system was complicated by the triangular shape of this sloping field. The lie of the land made it impossible to set the ridges parallel to one another; instead, there are bundles of parallel strips tailored to make the maximum use of the site. The slight curve at both ends of the strips is caused by turning the plough; this is the characteristic reversed "S" of ridge and furrow cultivation.

THE NEW FOREST ▶

William the Conqueror set aside vast areas of England as Royal Forests, where he could indulge his passion for hunting deer and other game. The New Forest in Hampshire is the most famous of these. To the Normans, a "forest" was not necessarily wooded; it was, rather, a game preserve owned by the king, subject to its own regulations about land clearance, poaching and trespass. These were policed by Forest Courts, which raised considerable revenue for the crown. They imposed fines and sold licences for limited farming activity. To the medieval kings, the open heathland shown in this photograph was just as much a "forest" as the dense woodland on the left. In fact, the serried ranks of dreary conifers, so beloved by the Forestry Commission, would not have interested William the Conqueror, as they support hardly any wildlife.

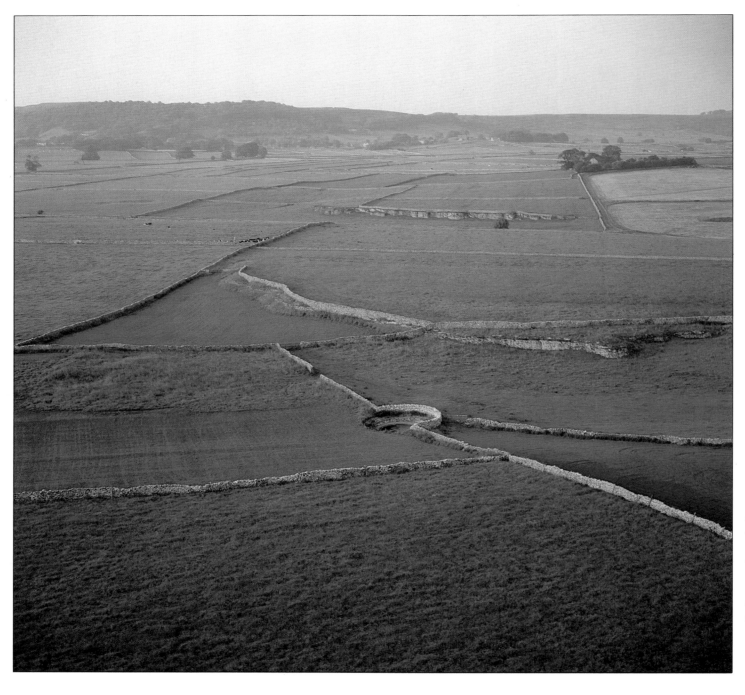

◄ DRY-STONE WALLING
To the north-west of Chatsworth, in Derbyshire, a patchwork of fields is enclosed by dry-stone walling. The regularity of the boundaries suggests that this is a landscape produced by Parliamentary Enclosures of the 18th century. It is interesting to see how the well in the middle of the photograph dictates the shape of the fields: there is a semicircular bulge in the wall as it skirts the well, and on the right, one of the fields is triangular, presumably to give it access to the well.

FIELD PATTERNS ►
Ghostly lines show up on this field near Ripon in Yorkshire, picked out by the low angle of the sun. Sets of parallel lines give the field the appearance of a sheet of card which has been pleated and then smoothed out. These probably represent earlier strip-farming methods, swept away when the field was enclosed. Less distinct is the so-called "envelope" pattern. This pattern is usually caused by farm machinery turning in opposite corners and is most often seen in newly sown fields of crops. There is a third set of faint lines running at about thirty degrees to the parallel lines. The cows, with their exaggerated shadows, seem blissfully unconcerned with these historical niceties.

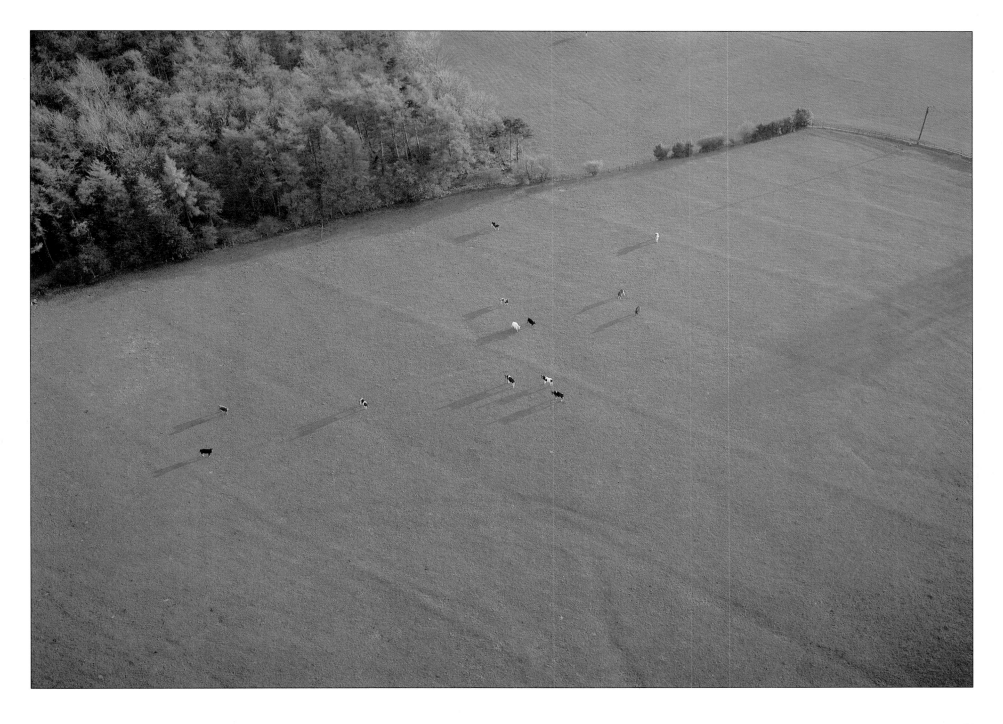

SAILING AT MORSTON

Sailing boats work their way down Morston Creek and out into Blakeney Harbour in Norfolk (right). At high tide both the harbour and the creek fill up to provide sailing in sheltered conditions; at low tide (left) there is only a thin ribbon of water here, revealing a landscape of mud and sandbanks. The harbour is protected by Blakeney Point, a shingle spit built up by the action of the North Sea. Blakeney Point, owned by The National Trust since 1912, and Morston Marshes are an important nature reserve with numerous wading birds and a colony of seals. I love this part of Norfolk and spend most of my holidays here. But this is very frustrating country from a balloonist's point of view: Norfolk is one of the windiest counties in England, it has the sea on two sides, and military aircraft practise low-level bombing runs and dogfights. But if there is a spell of settled weather I usually manage a couple of flights during the summer months.

THE NATIONAL TRUST

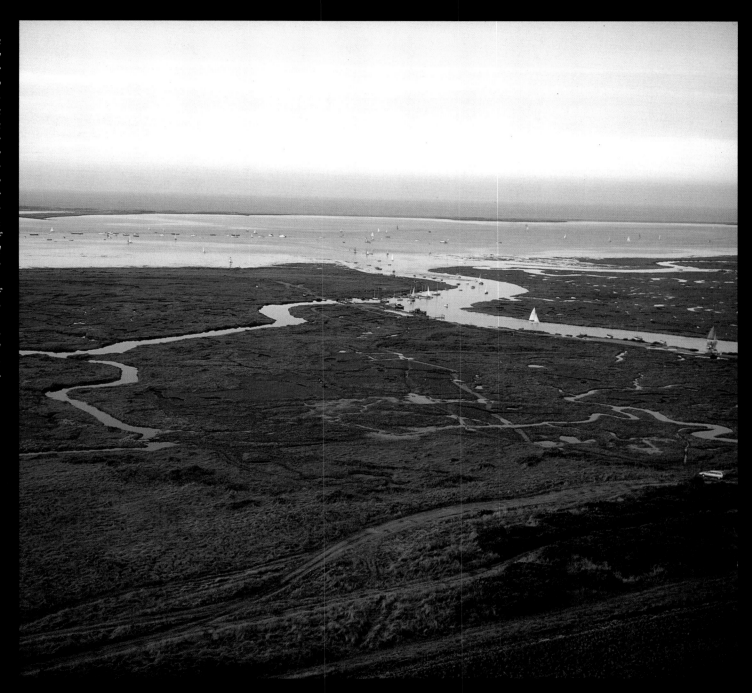

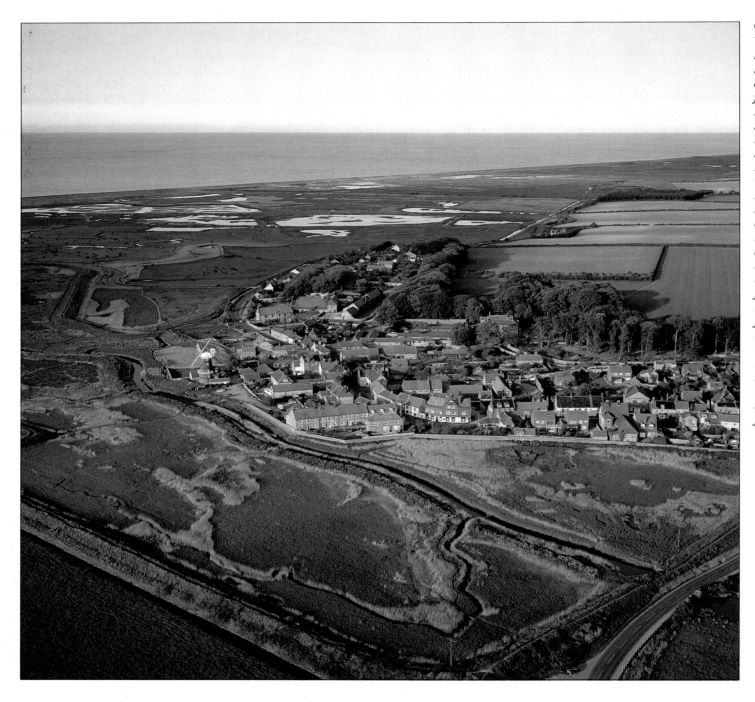

CLEY-NEXT-THE-SEA

The area around Cley-next-the-Sea in Norfolk has changed dramatically since the 15th century, when Cley was a prosperous town with a large fishing fleet and considerable trade with the Low Countries. In the 11th century, the shoreline followed the road that runs through Cley. By the 15th century the sea had been pushed back, but quite large ships could still sail up the Glaven River to dock well inland, to the right of the modern bridge seen at the bottom of the photograph. In the 16th century larger ships, some over 100 tons, needed deeper water. This forced a shift northwards, and a harbour was built next to the windmill. In the 1640s embanking schemes prevented the tide flowing up the estuary and, more recently, the sea has been pushed still further north as local farmers drained the salt-marshes for grazing cattle. The farmer's gain was the seamen's loss, for land reclamation led to the harbour silting up completely. Today local crab fishermen go to sea from the shingle beach at Cley, open to the full force of the North Sea.

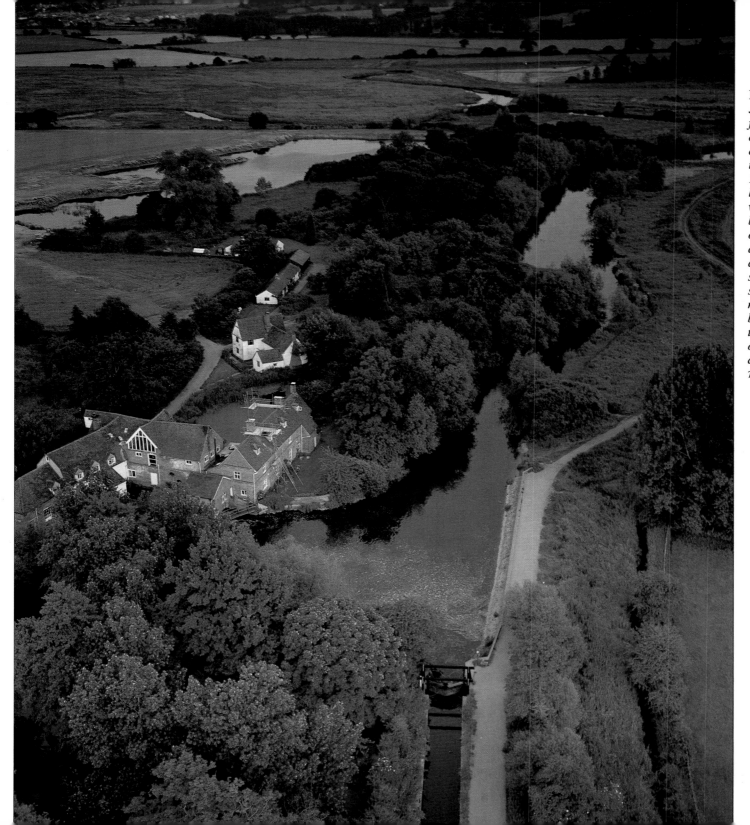

FLATFORD MILL

John Constable was brought up at Flatford Mill in Suffolk which his father owned. It provided the setting for several of his most famous paintings, including "The Hay Wain". In the early 19th century, road transport was unreliable and, wherever possible, goods were sent by water. The River Stour had been turned into a canal with a series of locks and was navigable for some distance inland. The lock at Flatford also provided the mill with a power source and farms throughout Suffolk sent their corn to be ground here. The meal or flour was then loaded on to barges which carried it downriver to the nearby port of Harwich and then on, around the coast, to supply the London market.

THE NATIONAL TRUST

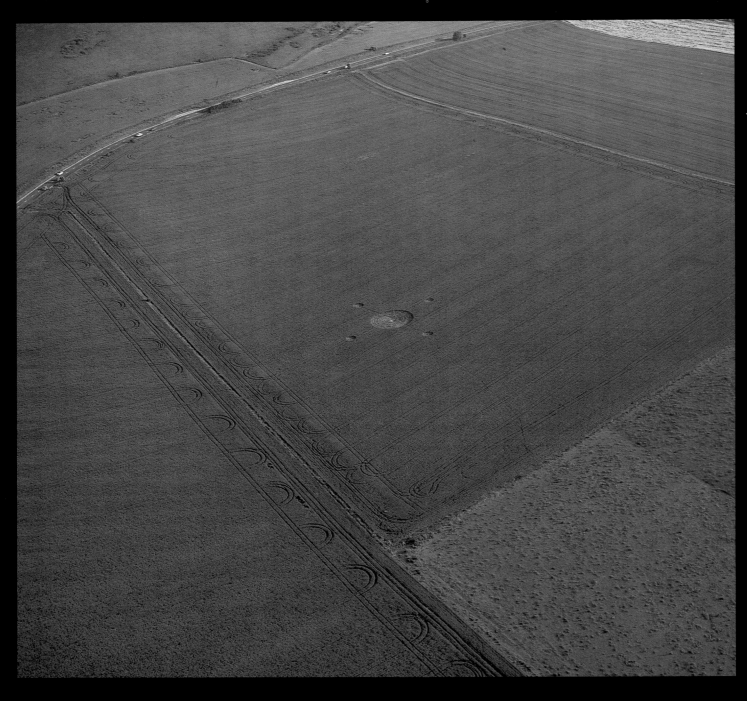

◄ MYSTERY MARKS

I was flying over the South Downs near Brighton when I saw this mysterious pattern in the crops. Over the last few years these crop marks have appeared in increasing numbers, usually at the foot of a hill after a spell of hot weather (as in this case). Despite extensive military and scientific research, they remain a mystery. Are they really landing sites for UFOs, or are they an elaborate hoax? Or is there a meteorological explanation? Could the sun beating down on the hillside generate local whirlwinds powerful enough to flatten the crops? The smaller circles may be explained by vortices spinning off from the main body of the whirlwind.

STUBBLE BURNING ►

In the 1970s and 1980s stubble burning became a familiar sight in the autumn, as intensive farming methods encouraged farmers to get rid of their straw by burning it. In traditional mixed farming the straw was used as fodder. But most arable farmers today do not have enough livestock to use up the straw, and it is not worth baling it up as fuel. The simplest solution is to burn the straw in the fields: the heat kills off disease and fungus in the earth and the soil is enriched with potash. However, the government has now banned the practice – the smoke caused local pollution, hedgerows were sometimes engulfed in the flames and there was a toll on insects living in the fields, with consequences for birds and other animals higher up the food chain. For aviators, including balloonists, this will make autumn flying easier and safer, as the build-up of atmospheric haze led to seriously reduced visibility at this time of year.

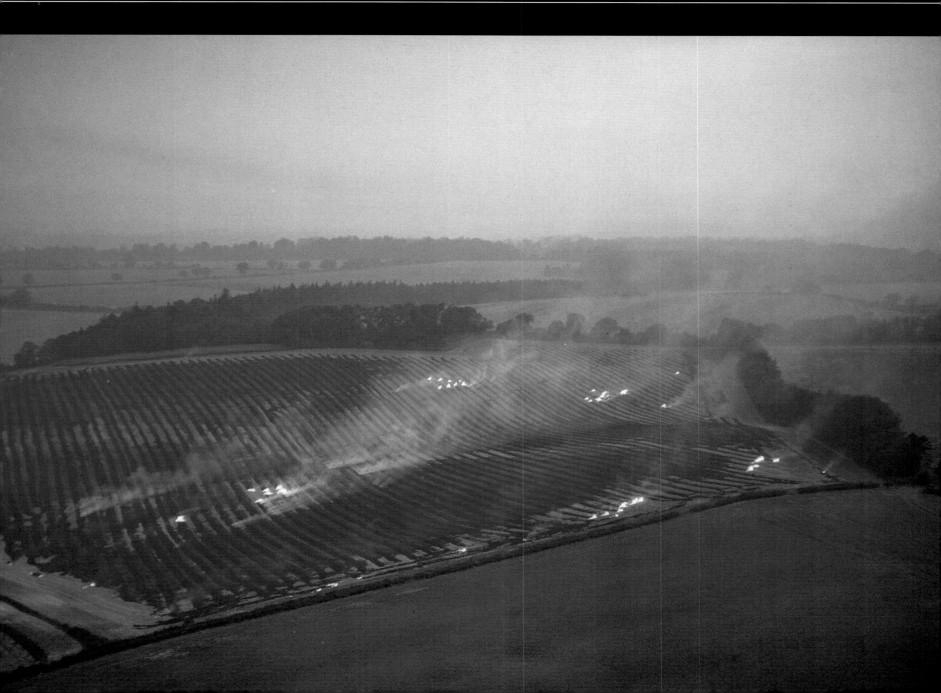

PALINGS LAGOON

I was flying over the charmingly named Moisty Knowl in Derbyshire when I saw this intriguing pattern at the water's edge. This is a "palings lagoon", created by pumping out slurry from a nearby fluorspar mine. There are four such lagoons in the Stoney Middleton area. When they are full of slurry, they are dried out and grassed over except for a small area of water which is kept as a nature reserve. Fluorspar is mined to manufacture hydrofluoric acid, an essential ingredient in the production of chloro-fluoro-carbons or CFCs, which are used in aerosols, refrigerators and foam packaging. There is growing pressure for CFCs to be banned, as they damage the ozone layer which protects the Earth from harmful radiation. Fluorspar, or fluorite, occurs abundantly in Derbyshire (it is often called Derbyshire spar); the ornamental variety known as Blue John comes from Castleton, a few miles away.

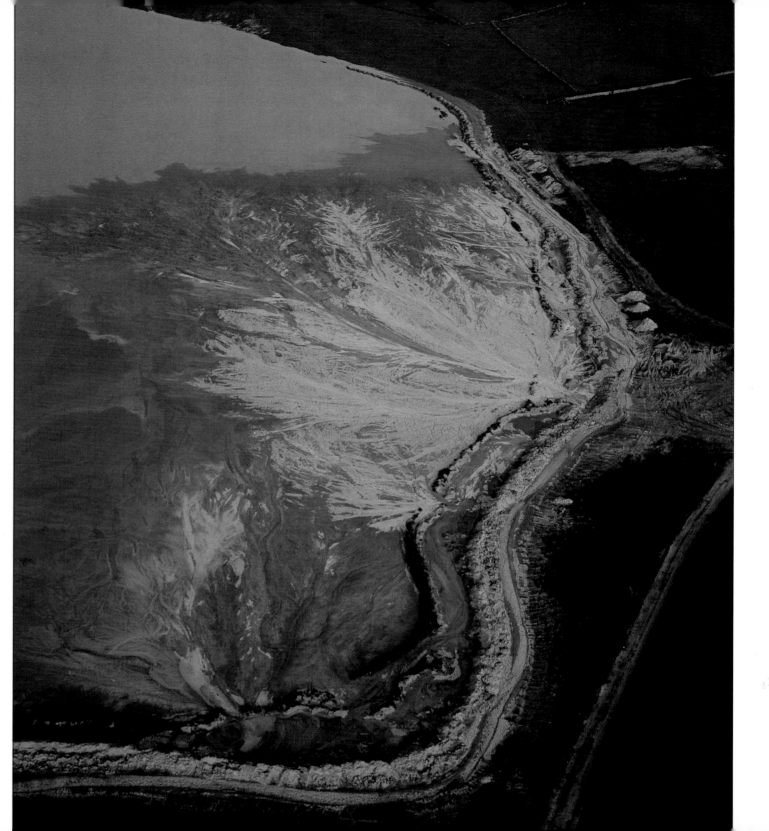

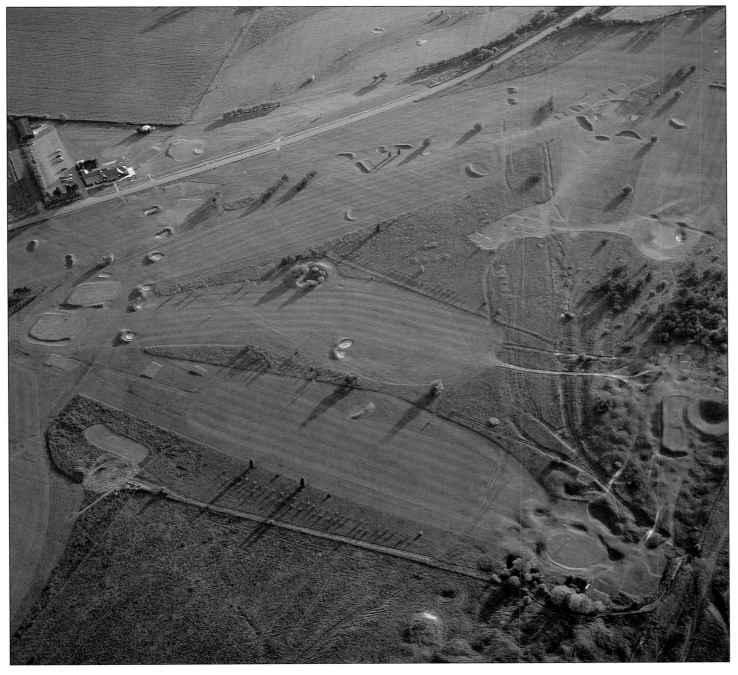

EARTHWORKS

Whenever I fly over the Downs of southern England I look out for prehistoric earthworks. The country near Avebury in Wiltshire is rich in standing stones, burial mounds and hillforts. When I first saw this collection of crescent-shaped marks at the foot of Calstone Down in Wiltshire, I thought it must be yet another relic of England's early civilization. Only when I looked through my telephoto lens did I realize that this was a golf course! The crescents are bunkers, the rectangular platforms are the greens and the corduroy-like strips are the fairways. The clubhouse is across the road. There are prehistoric burial sites in the rough ground at the bottom right of this photograph, but everything else is quite modern.

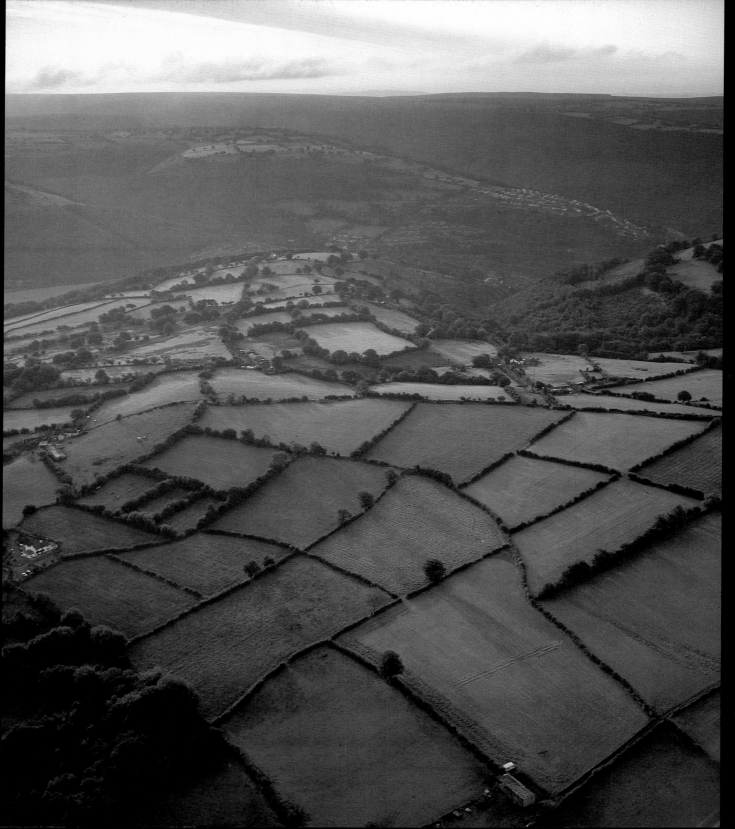

◄ PATCHWORK FIELDS
To the north-west of Newport i
the landscape alternates betw
unattractive monotony of
Commission conifer plantati
the delightful patchwork of fie
here. The fields are as regular
as the hilly terrain allows, a
buildings nestle in sheltered c
the lower fields.

ANCIENT COUNTRYSID
The irregular shapes of the fie
of Sevenoaks in Kent suggest
landscape has evolved gradual
than being laid out all at once
an area of ancient country
opposed to the planned cou
created by 18th-century Parlia
Enclosures. The winding an
hedgerows which are so chara
of ancient countryside show
ticularly well against a back
snow-covered fields. Peopl
assume that we can't go ballo
the winter. In fact, I have made
my most beautiful and excitin
at that time of year. In winter
able wind conditions frequently
and the only technical probler
fuel pressure is reduced
weather. This can be overc
warming the tanks or by pres
them with compressed nitrog
we can land in any field protec
good blanket of snow; at the en
flight, as the balloon dragge
the surface, I found myself "to
ing" uphill!

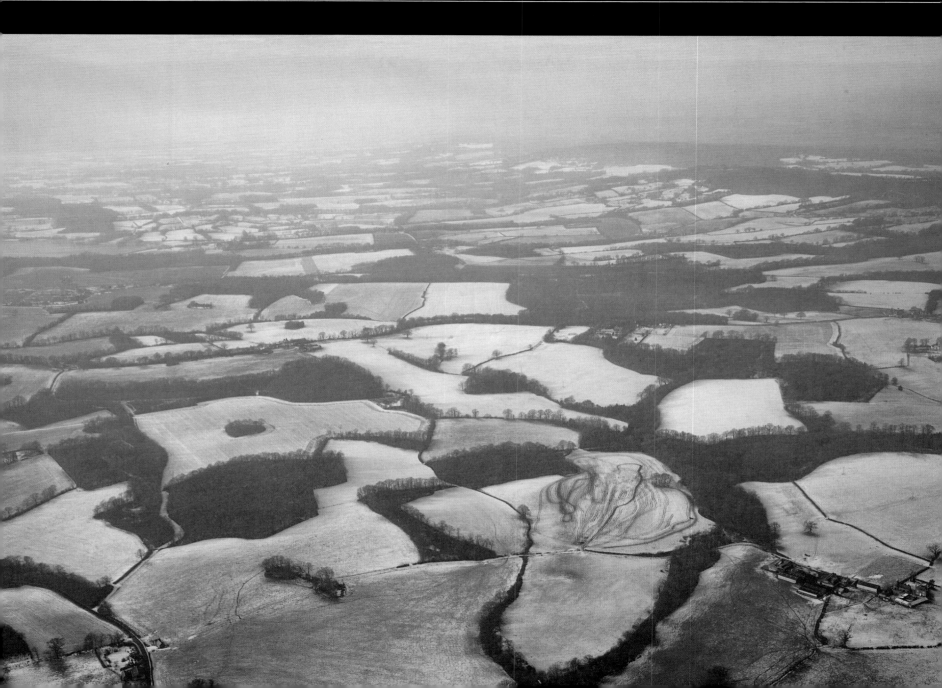

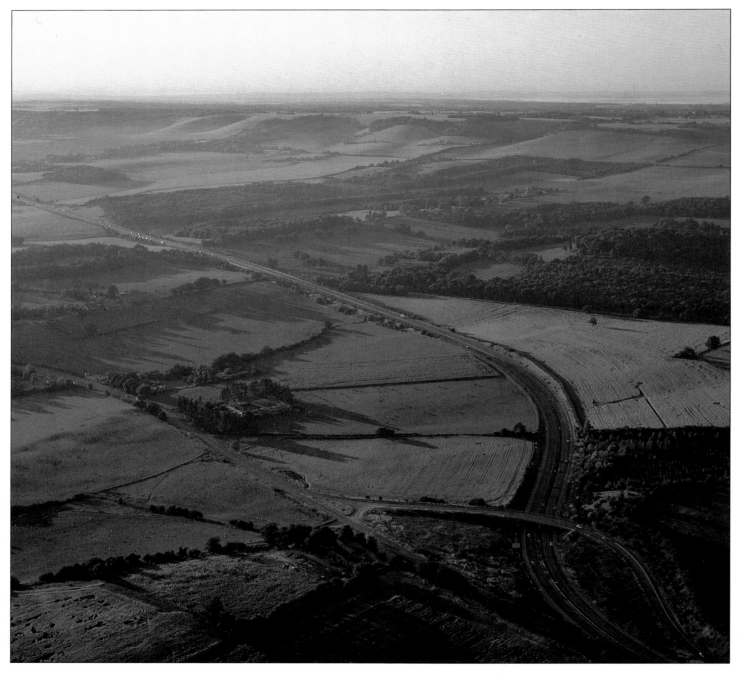

◄ MOTORWAYS

At Maidstone in Kent the M20 joins up with the A20, the road it was built to replace. The old A20 was the main road from London to the Channel port of Folkestone and all the traffic used to run through the middle of Maidstone itself. Now a fly-over allows vehicles to join the coast-bound carriageway. The M20 runs parallel to the old Pilgrim's Way on the top of the North Downs, but the traffic moves at a speed that would have astonished Chaucer's pilgrims.

ROAD JUNCTIONS ►

From the air, there is a symmetrical elegance in the layout of this road junction on Dartmoor. No less than five minor roads converge here on the A38, the principal road in south Devon, which carries holiday traffic to the coasts of Devon and Cornwall. The planners have gone to considerable lengths to provide safe entry and exit routes to and from the A38, as well as a road bridge and subsidiary roundabouts. There is also a railway tunnel running directly underneath the junction: the track can be seen as it disappears (top left) and re-emerges (bottom right). The pylons, seen in the top half of the photograph, carry high-voltage power lines parallel to the road. At the end of this flight I was becalmed over these wires and had to wait half an hour before there was enough wind to carry me to a safe landing.

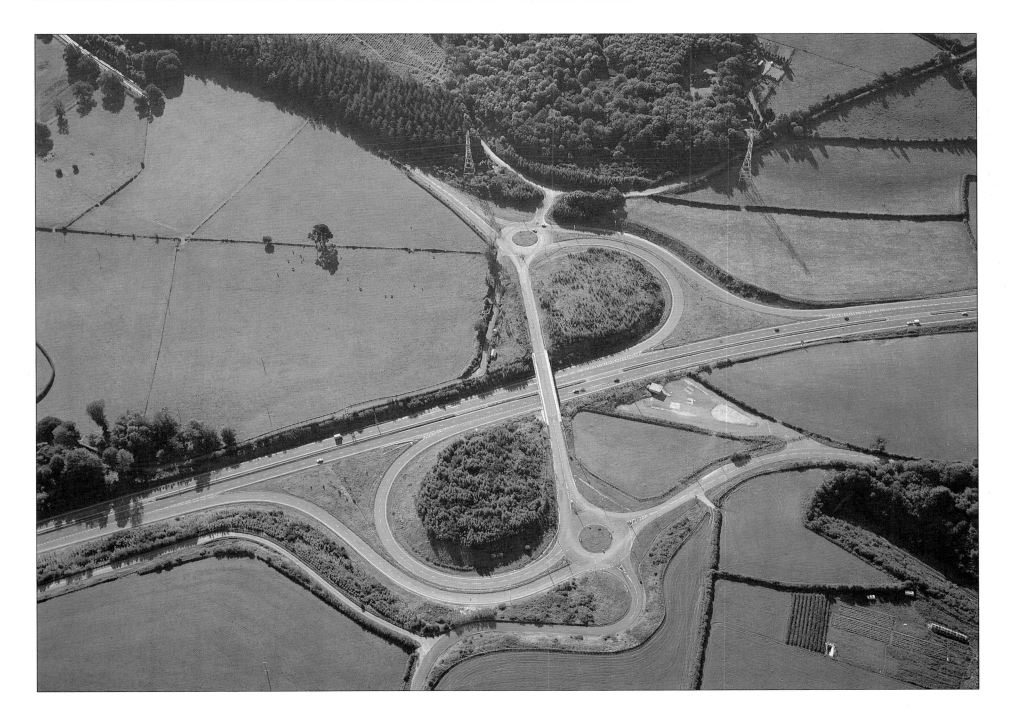

Warfare and Worship

The castles, cathedrals and monasteries which survive from the Middle Ages, even if as dilapidated ruins, give us an image of a society dominated by warfare and worship. Perhaps it is really the enduring quality of the stone used in the castles which makes this period seem so heavily militarized; maybe ordinary people pursued their lives without ever falling foul of the local baron or his knights. On the other hand, it would have been very difficult to escape the influence of the medieval church, whose wealth and power is reflected in the profusion of parish churches, cathedrals and monasteries in every part of the country. In an effort to escape from the temptations of worldly life, the Cistercians deliberately chose remote and desolate locations for their abbeys, as at Tintern and Rievaulx, and so it is easy to find balloon launch sites close to these ruins. But I have found it impossible to get photographs of the great cathedrals in the centre of cities such as Norwich, Salisbury or Canterbury, or of castles which are in towns, although I have been able to fly from Bodiam, Leeds and Chirk, all of which are in open country.

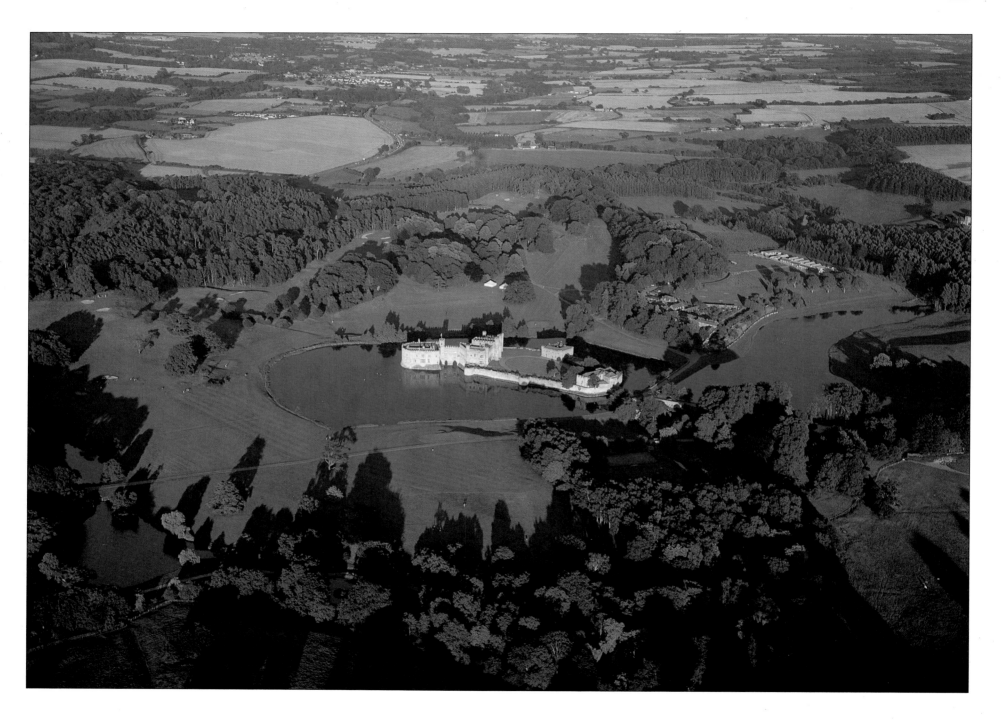

LEEDS CASTLE

My logbook records more flights beginning at Leeds Castle in Kent than anywhere else. Indeed, it was at Leeds that I first climbed into a balloon basket, and later on I flew my first tentative solo from here. This is the perfect balloon launch site. The high-level view (left) shows how it is ringed with trees, providing excellent shelter from any wind direction. It is well away from controlled airspace and there are not even power lines to worry about. Leeds Castle takes its name from a Saxon nobleman called Ledian, or Leed, who built a wooden fort here in 857. This was taken over by the Normans and replaced with a stone building, of which nothing remains. The earliest surviving parts of the castle were built by Edward I for his queen, Eleanor of Castile, in the late 13th century. Since then Leeds Castle has had many alterations, notably the turreted south front, looking onto the oval lawn (right), which was added in 1822. But the great beauty of Leeds, its moated setting, is original. The River Len was dammed to provide the water supply for the large moat, which has two islands. In the centre of the moat, on a smaller island, sits the gloriette, *which housed the living quarters for the royal household. This, as well as the exquisite arched bridge which links it to the rest of the castle, is also original. The Great Water, to the south of the castle (left), is a recent addition.*

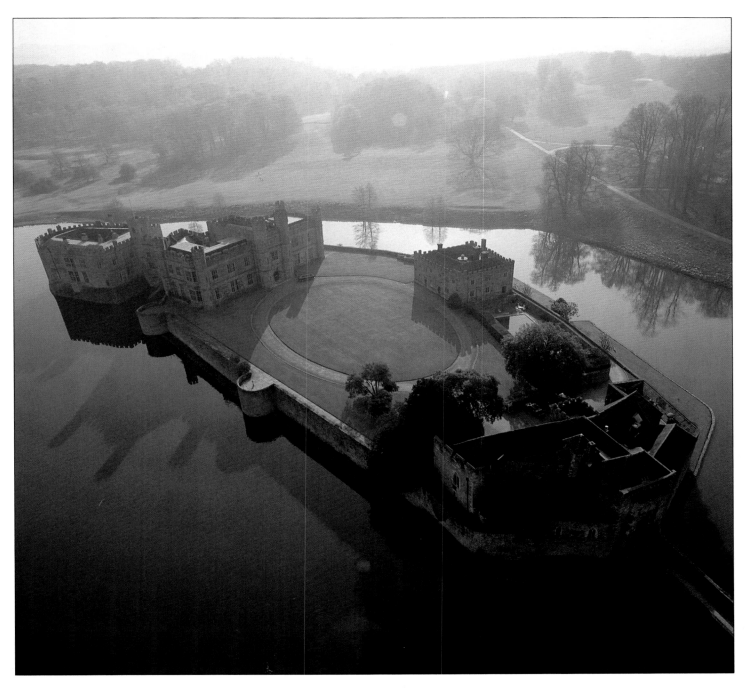

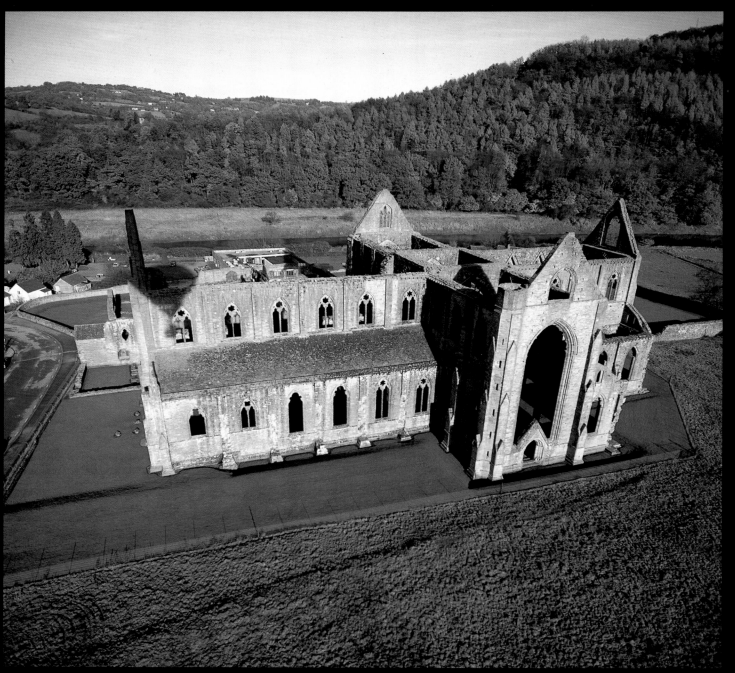

TINTERN ABBEY

Tintern Abbey was founded by the Cistercians in 1131 on the banks of the River Wye in Gwent. Not much is left of the original buildings, as the abbey was considerably enlarged in the 13th and 14th centuries. The ruins we see today date from around 1300 when Tintern was at the height of its wealth and power. At that time it owned some 3000 sheep, and the monks and lay brothers had done much to exploit the landscape – clearing woods, draining marshes and setting up outlying settlements or granges. The monastic buildings lay within a twenty-seven acre enclosure bounded by a perimeter wall. The great church itself had been built on the scale of a cathedral and it was the wealth of houses such as Tintern that led Henry VIII to seize their assets at the Dissolution of the Monasteries in 1536. Within a few years the lead had been stripped from the roof and Tintern had been reduced to one of our most famous and romantic ruins.

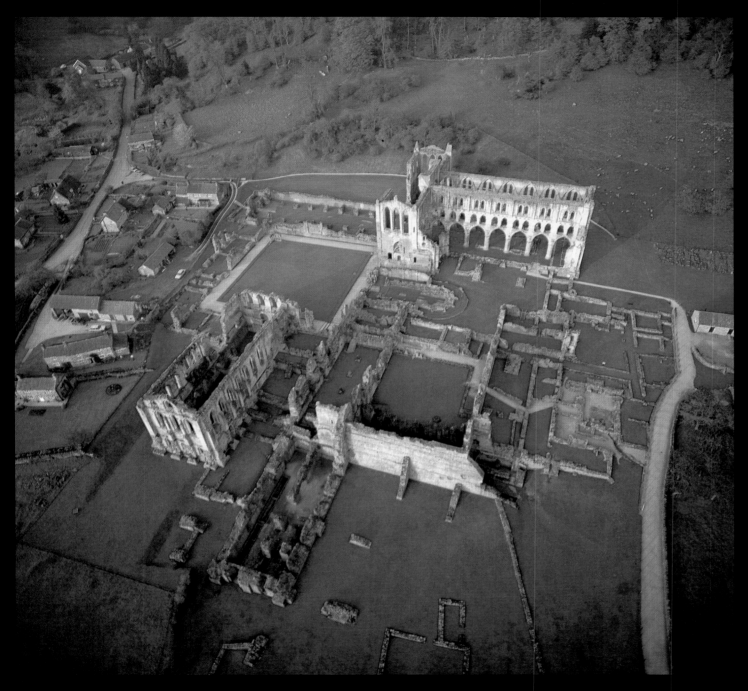

RIEVAULX ABBEY

The Cistercians founded the Abbey of Rievaulx in 1132, seeking simplicity and seclusion in its remote setting. They chose a valley in the Yorkshire hills as part of their quest for a life of austerity, rejecting the worldliness and wealth of older orders of monks such as the Benedictines. But the Cistercians were soon caught up in worldly success themselves and by the end of the 12th century there were over 140 monks and 500 lay brothers. They engaged in sheep farming on a grand scale, grazing their flocks on the limestone hills above the abbey, while in the valleys establishing arable farms. The abbey also had many granges, or satellite settlements. The wealth all this generated is reflected in the splendid monastic buildings at Rievaulx. At the top of this photograph can be seen the remains of the great church: the choir is a particularly fine example of Early English Gothic. It was built in the 1220s and, although it has lost its roof, is still largely intact. The Cistercians' ambitious building programme ran the monastery into debt and by the Dissolution of the Monasteries in the 16th century, there were only twenty-two monks living there.

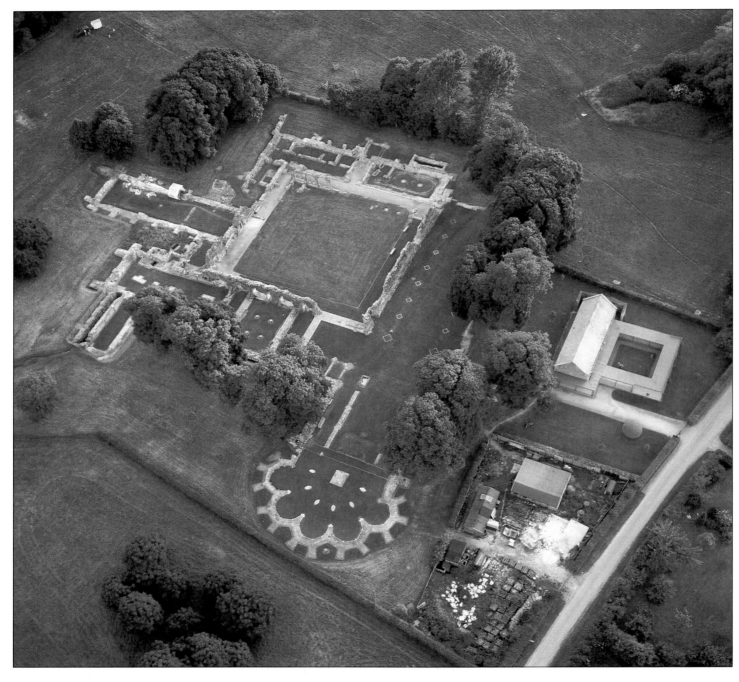

◄ HAILES ABBEY

When Richard, Earl of Cornwall, was in danger of being shipwrecked, he pledged to endow an abbey if he escaped. His prayers were answered and his brother, King Henry III, gave him the manor of Hailes so that he could fulfil his promise. Hailes Abbey in Gloucestershire was founded in 1246. The Cistercian abbey became famous as a place of pilgrimage when it acquired a relic of Christ's Blood (guaranteed authentic by the Pope). It was to house this relic that the eastern end of the church was rebuilt in the 1270s. From the air this looks like half a cog-wheel. At the top of the photograph is the cloister, the only part of Hailes standing above ground. The abbey was closed down in 1536 and the buildings were later ransacked for their stone.
THE NATIONAL TRUST

CHIRK CASTLE ►

Chirk Castle in Clwyd was built at the command of Edward I, as part of his campaign to subdue the Welsh and to protect the Welsh Marches from attack. Completed in 1301, its hilltop situation gives it commanding views over the surrounding countryside. Chirk is not massive, but its strong walls and rounded corners ensured that it could withstand all but the most determined attack. Its exterior has survived unaltered and the castle has been occupied continuously since its completion.
THE NATIONAL TRUST

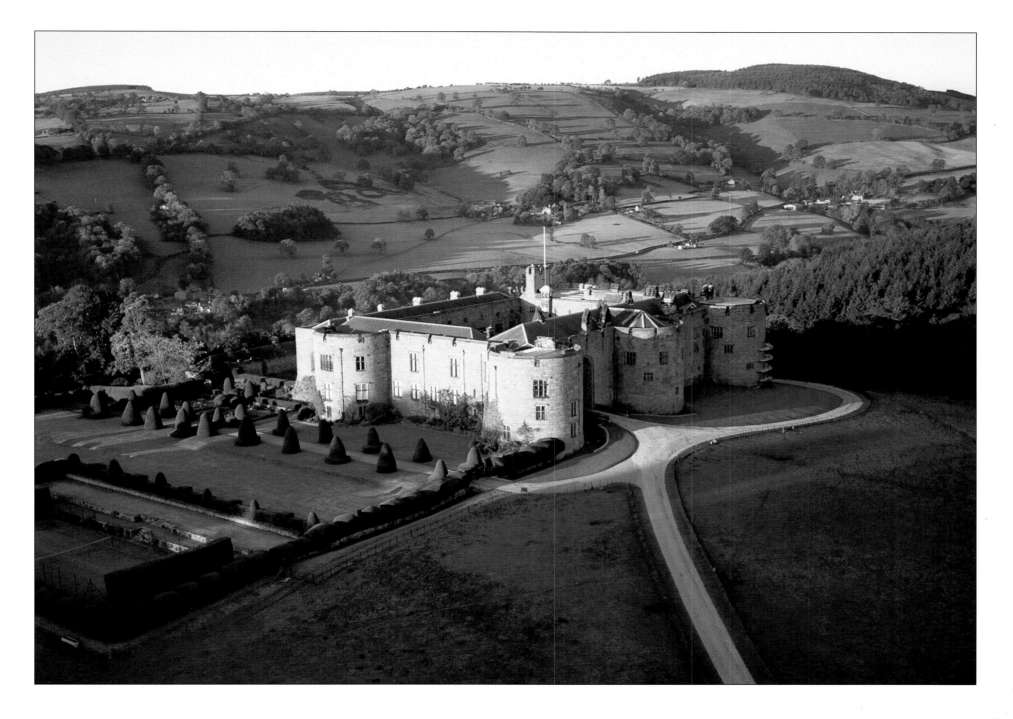

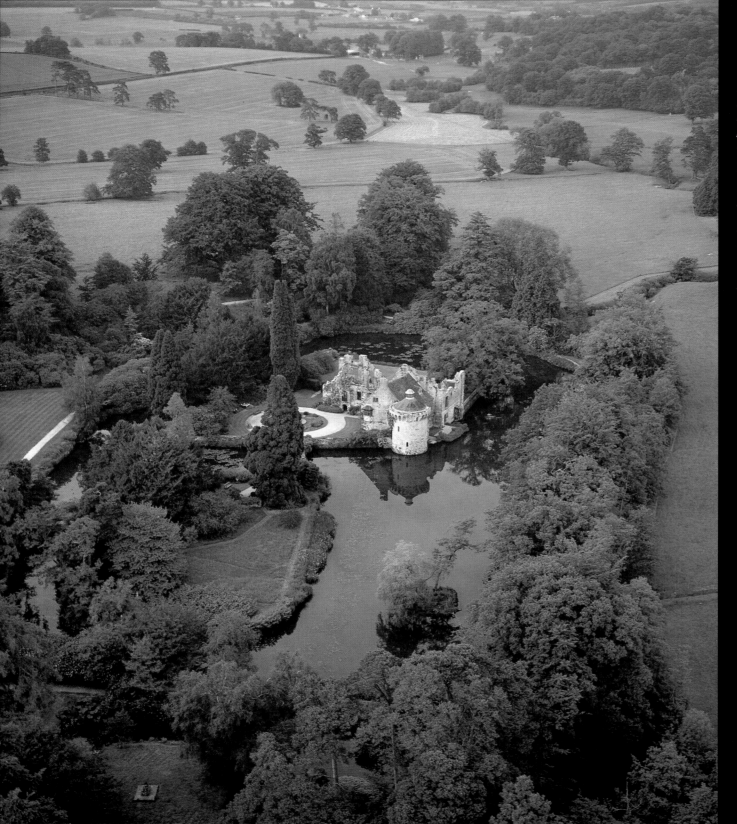

SCOTNEY CASTLE

Scotney Castle in Kent was built by Roger Ashburnham in the 1370s on a pattern similar to that of Bodiam: a rectangular plan, with four corner towers and curtain walls. Within the walls he built a manor house, but only the south tower and the base of a gatehouse survive. The River Bewl and its tributary, the Sweetbourne, were diverted to form the moat. Further building was carried out in the 1580s by Thomas Darrell, a Roman Catholic. This was the time of the Spanish Armada, when Catholics were perse-cuted in England. When Darrell rebuilt the south wing he incorporated into the staircase several secret hiding holes so that he could shelter Catholic priests. The pretty conical roof and lantern were added in the 17th century.
THE NATIONAL TRUST

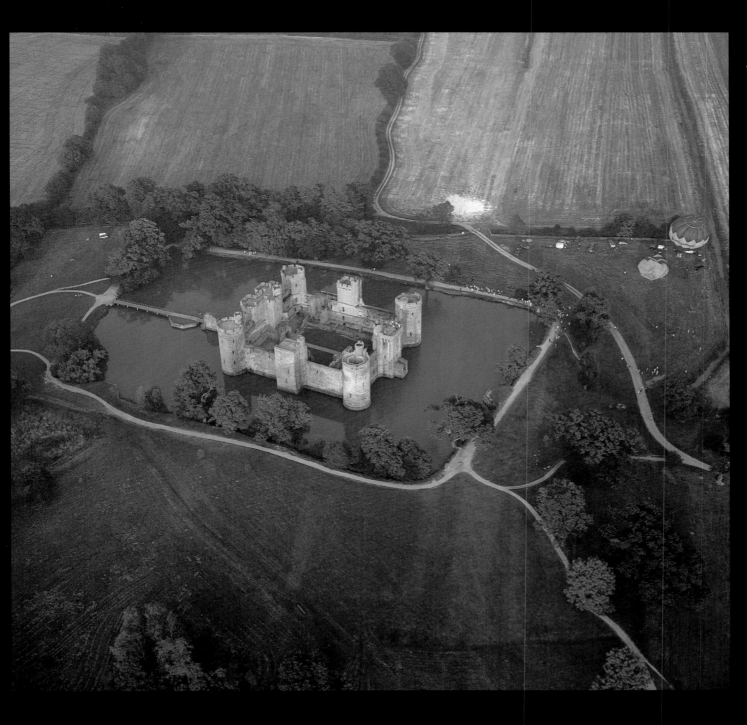

BODIAM CASTLE
In 1385 French raids on the coast prompted Richard II to order Sir Edward Dalyngrigge to "strengthen and crenellate his manor house" at Bodiam in Sussex. But the French never came, as the English controlled the Channel again by the time work was completed in 1388. Seen from the air, Bodiam's is a perfect symmetrical plan: the four corners with their round towers frame a rectangular courtyard. The curtain walls on each side are broken with square towers, while on the north is the gatehouse leading to the causeway across the moat. The gatehouse, with its two towers and machicolated parapet, is the most heavily defended part of the castle. It had portcullises which not only protected it against external attack but also from the courtyard in case of treachery. (See also jacket.)
THE NATIONAL TRUST

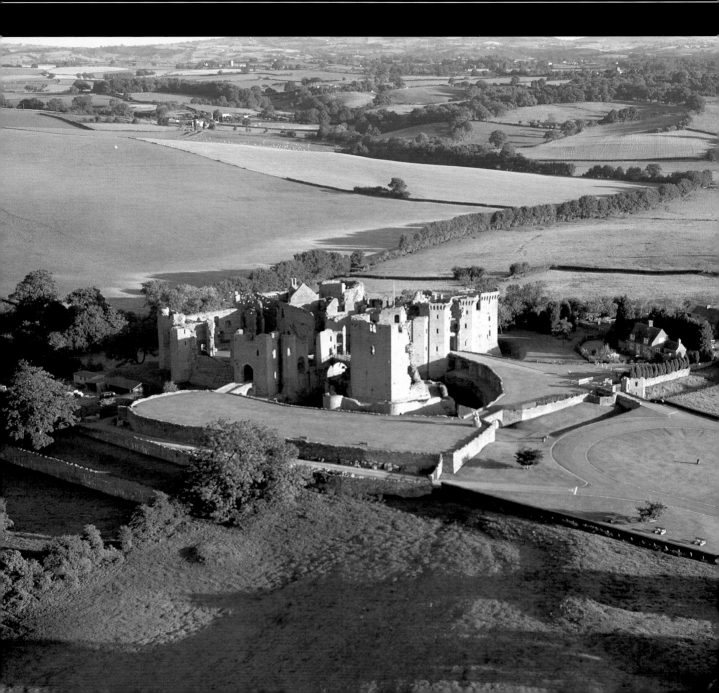

HERSTMONCEUX CASTLE

One of the earliest brick buildings in England, Herstmonceux Castle in Sussex was constructed in the 1440s by Sir Roger Fiennes. Although protected by a moat, it was built as much for comfort as military strength and appears to have been modelled on Bodiam; both have impressive gatehouses guarding the entrance from the causeway and both have corner towers to protect the curtain walls. At Bodiam the walls rise from the water but here they sit on a platform, which must have been convenient for any attackers! In fact Herstmonceux never was attacked. It eventually fell into decay but was restored early this century. From 1948 to 1988 it was used by the Royal Observatory. Its fate is now uncertain.

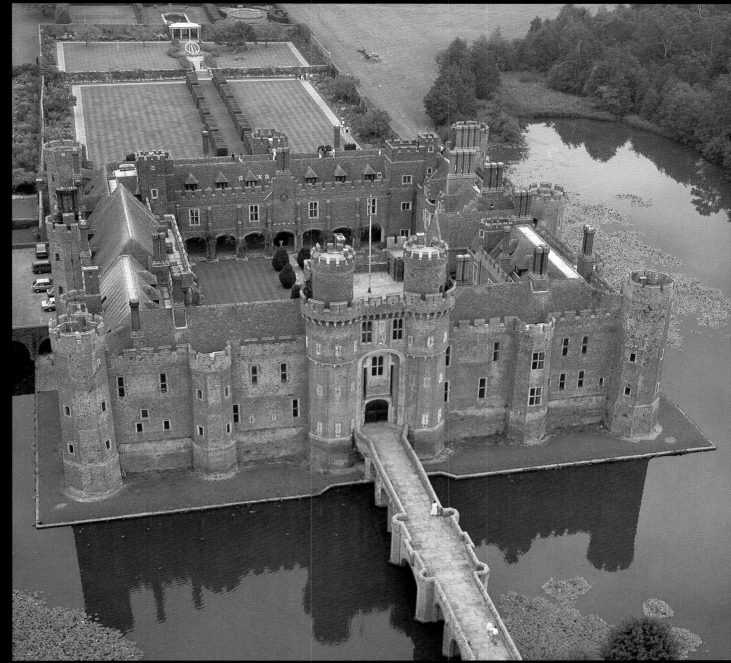

Houses and Parks

Bird's-eye views of country houses were fashionable at the end of the seventeenth century. They were done from an imaginary viewpoint, about two or three hundred feet above the ground, and show the house in the context of its gardens which at that time were usually very elaborate formal designs of parterres and terraces. As an architectural photographer working mostly in historic houses, I have always been fascinated by these views and they inspired me to take up ballooning. I wanted a viewpoint high enough to see over the house to the garden or park beyond, but not so high that the view of the façade is dominated by the roof. Later in the eighteenth century these formal gardens were replaced by the type of English landscape garden we associate with Capability Brown. With their emphasis on open parkland punctuated by clumps of trees, the parks he designed are ideal for the balloonist looking for a launch site. The parkland gives me plenty of room to lay out the balloon, the trees give me shelter from the wind and the open spaces between the clumps allow me to get airborne safely.

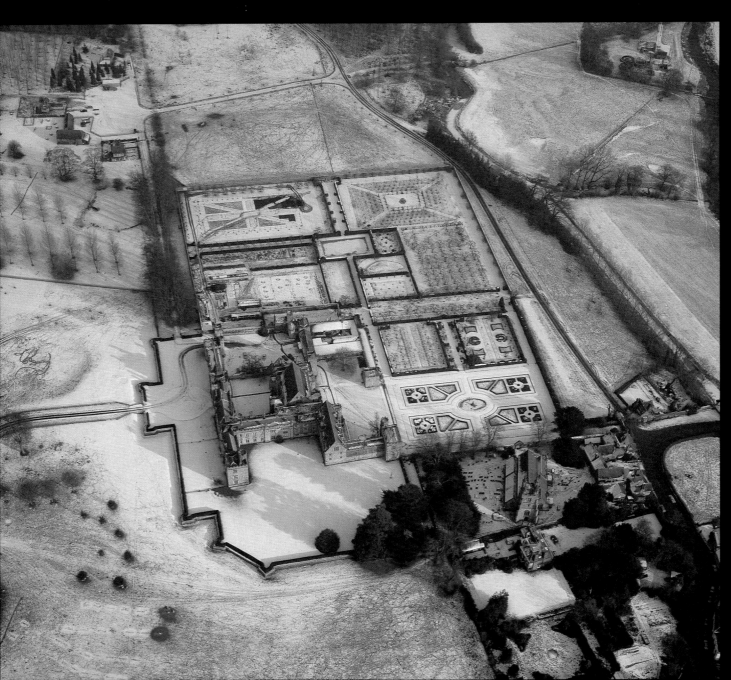

◄ **PENSHURST PLACE**

The Great Hall at Penshurst Place in Kent dates from 1341 when Sir John de Pulteney was given a "licence to crenellate". It has survived unaltered and shows in this photograph as the raised, pointed roof forming the central section of the "H" plan on which Penshurst is built. Later wings provided a buttery, pantry, kitchen passage and long gallery. The latter is in the Elizabethan west wing, facing the camera. The formal gardens are also originally Elizabethan. Penshurst is very fortunate to have escaped the 18th-century mania for "landscaping", which would have swept away these gardens. Quite by chance, I flew over Penshurst on a day when they were picked out by a light covering of snow.

KNOLE ►

In 1456 Knole, in Kent, was bought by Thomas Bourchier, Archbishop of Canterbury, for less than £270. He began building on a grand scale and by the time he died, thirty years later, Knole was one of the largest private houses in England. A later archbishop, Thomas Cranmer, gave up Knole to Henry VIII, who enlarged it but never lived there. In 1566 his daughter, Elizabeth I, gave it to her cousin, Thomas Sackville, and Sackvilles have lived here ever since. Knole's exterior, with its profusion of pinnacles, battlements, gables and chimneys, is much as Thomas Sackville left it. Built round seven courtyards – one for every day of the week – the house is also said to have 52 staircases and 365 rooms.

THE NATIONAL TRUST

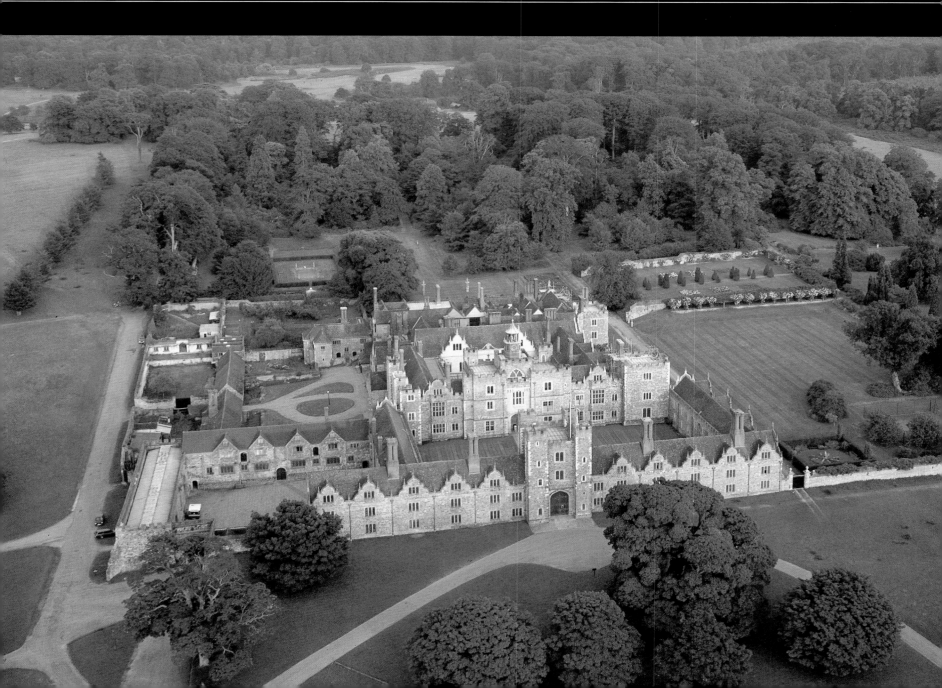

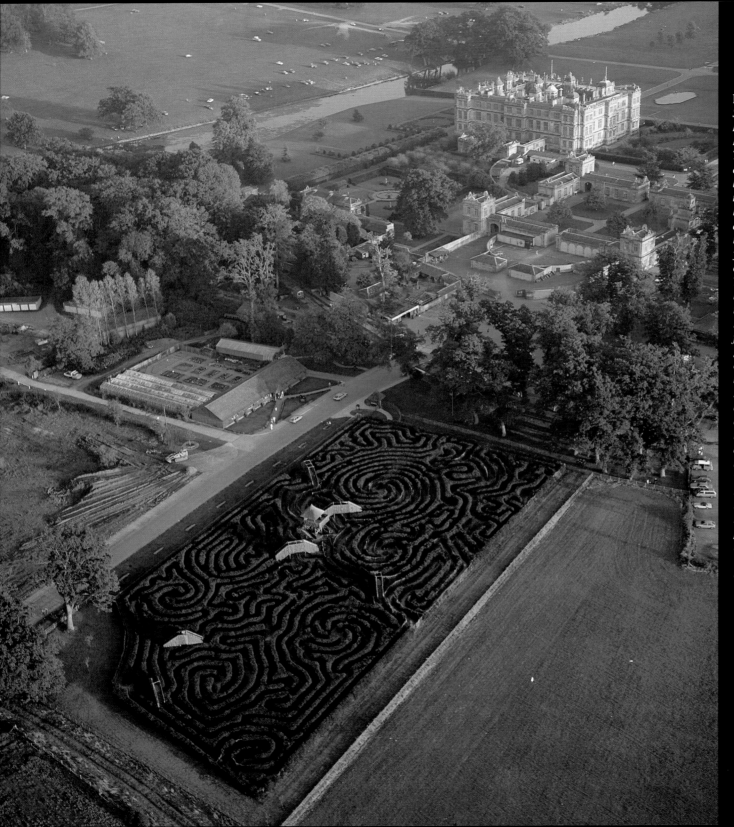

LONGLEAT HOUSE AND MAZE

Sir John Thynne was Comptroller of the Royal Household in the reign of Elizabeth I. The great courtiers of the Tudor age were able to amass considerable fortunes and Thynne, an astute businessman, was one of the richest men in the country. When his new house at Longleat in Wiltshire burned down just before it was finished, he was rich enough to start all over again with yet another plan. Longleat House was completed eight years later, in 1580. The design adopted elements from Italian and French Renaissance architecture, but the result is an authentically English masterpiece. Although it was finished eight years earlier than Burghley House, its classical restraint and elegant symmetry make it seem much more advanced. The park was landscaped by Capability Brown at the end of the 1750s. There had originally been extensive formal gardens, but a visitor to Longleat wrote in 1760: "The gardens are no more. They are succeeded by a fine lawn, a serpentine river, wooded hills, gravel paths meandering round a shrubbery, all modernized by the ingenious and much sought-after Mr Brown." More recently, a Safari park has been set up in the grounds to house the famous lions of Longleat. "The World's Largest Maze" (left) is one of the many other attractions.

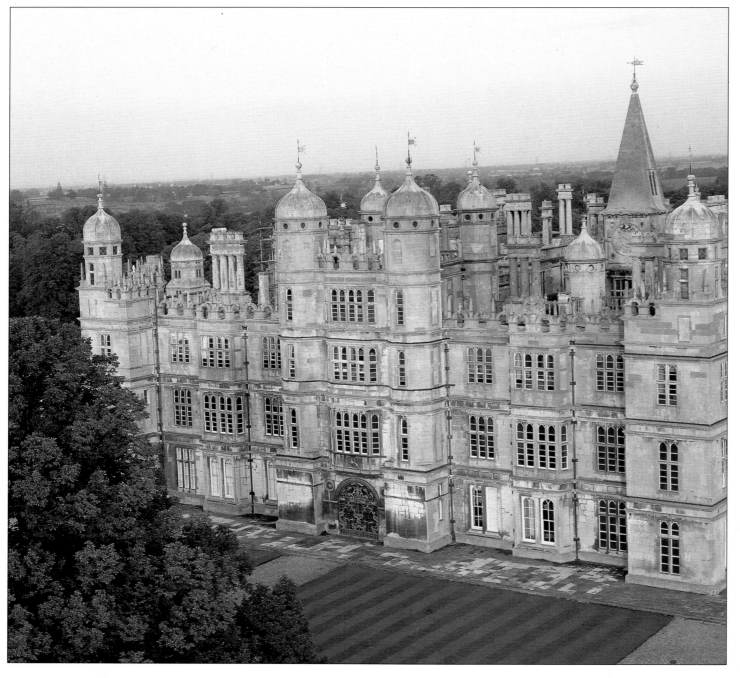

◄ BURGHLEY HOUSE

Like so many of the great houses of the Elizabethan period, Burghley House in Lincolnshire was once a monastery. It was bought by Richard Cecil after the Dissolution of the Monasteries in 1536. His son, William, who was created Lord Burghley in 1571, began building in 1556 but the house was not finished until 1589. It was built on a scale of lavish extravagance and splendour, to reflect its owner's political pre-eminence as Queen Elizabeth's Chief Minister. One of the functions of these so-called "prodigy houses" was to entertain the Queen and her retinue. To this end, there are magnificent State Apartments as well as Lord Burghley's private quarters. Burghley House is built round a courtyard dominated by the giant obelisk which crowns the clock tower.

HATFIELD HOUSE ►

Queen Elizabeth I spent much of her childhood at Hatfield House in Hertfordshire, which was then a royal palace. It was acquired from James I by Robert Cecil, his Chief Minister, who took the title Earl of Salisbury. Salisbury was not only a formidable politician (it was he who uncovered the Gunpowder Plot) but also an avid builder. In 1608 he built the present house, employing as his designer Robert Lyminge. The central block contains the State Apartments, including a marble hall two storeys high, a long gallery measuring 180 feet and a sumptuous drawing room. The wings were private rooms for James I's household and for the Earl himself.

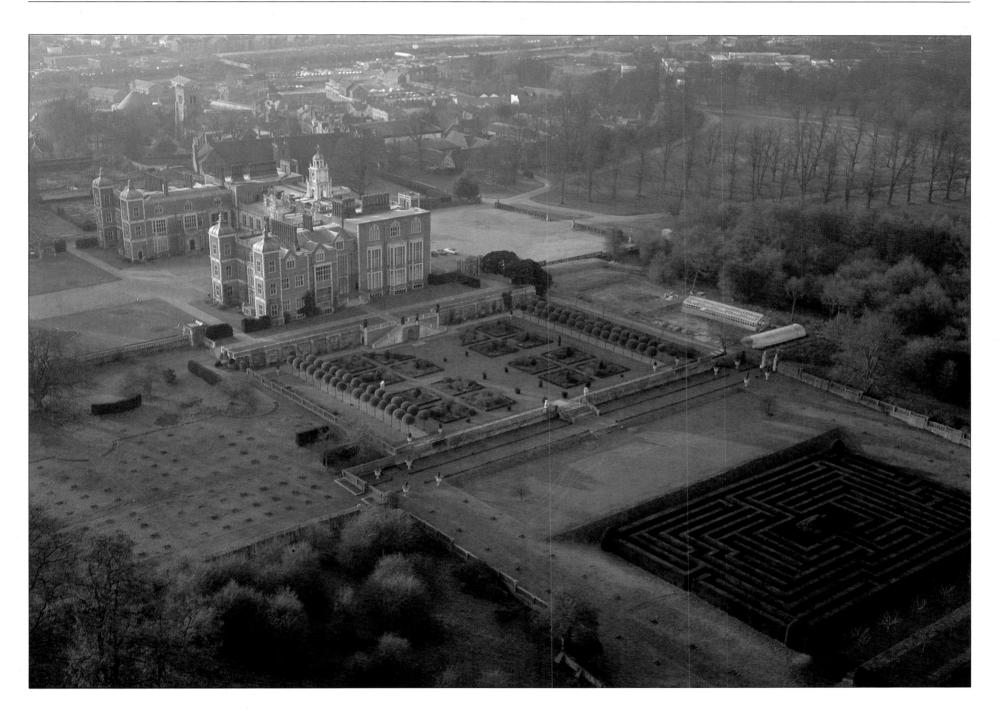

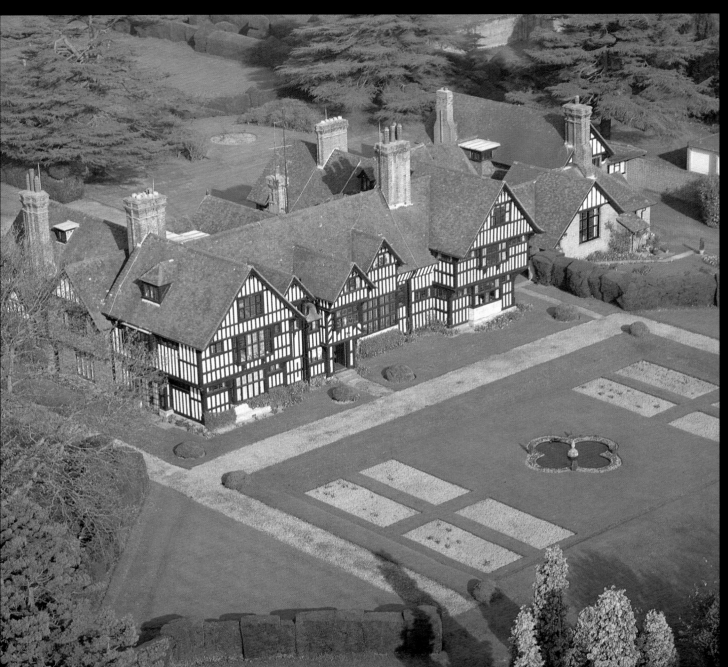

◄ RUMWOOD COURT

I was coming in to land at the end of a dawn flight from Leeds Castle when I flew over Rumwood Court in Kent. I owe an apology to the lady in a blue dressing-gown. She came out to investigate but when she saw the balloon, she took cover in the bushes to the right of the house. With the exception of the left gable, which is late 19th century, the east front of Rumwood Court dates back to 1599. Its close vertical lines, overhanging jetties and many gables are typical of the Tudor style. By the end of the Tudor period, a timber shortage and the increasing popularity of brick led to a decline in the number of such half-timbered houses.

LANHYDROCK ►

Most of the 17th-century house at Lanhydrock was destroyed by fire in 1881. Fortunately, the north wing, seen here, escaped. It houses the magnificent gallery, with its ornate plasterwork ceiling. Sitting on the edge of the granite mass of Bodmin Moor in Cornwall, Lanhydrock is itself built of local granite. The formal gardens were laid out in 1857, incorporating bronze urns made by Louis XIV's goldsmith, taken from the Château de Bagatelle. Lanhydrock belonged to the Robartes family for 350 years. In 1624 Sir Richard Robartes had his arm twisted by James I, who told him that he could either buy a barony for £10,000 or pay a fine of £10,000 for refusing! Robartes accepted the barony, which cost him about ten years' income. When I flew over Lanhydrock at the end of October, the roses were still flowering in the mild climate of the Cornish Riviera.
THE NATIONAL TRUST

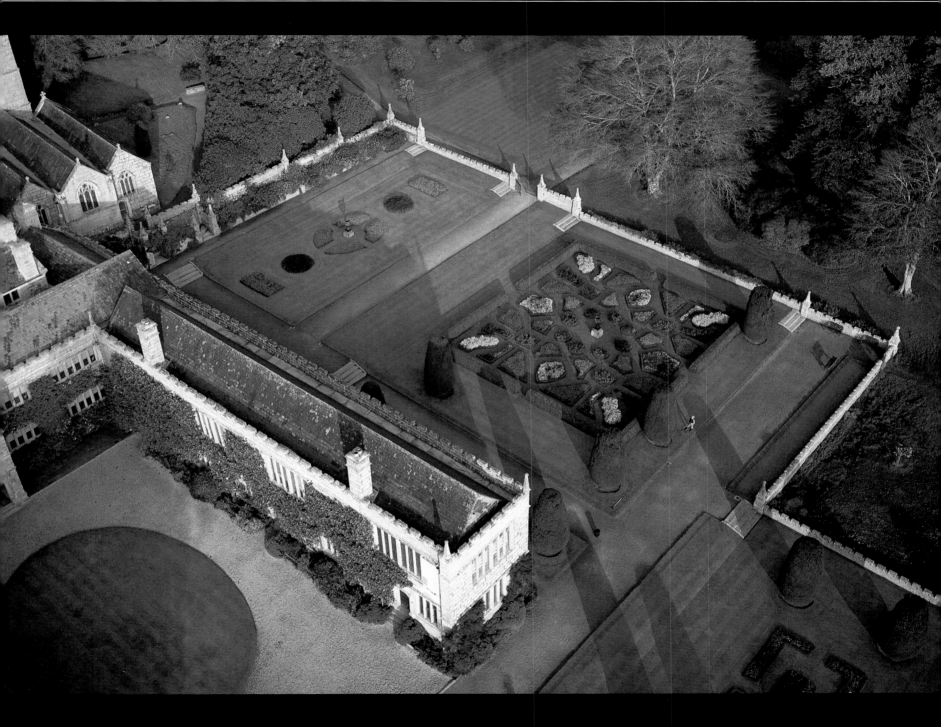

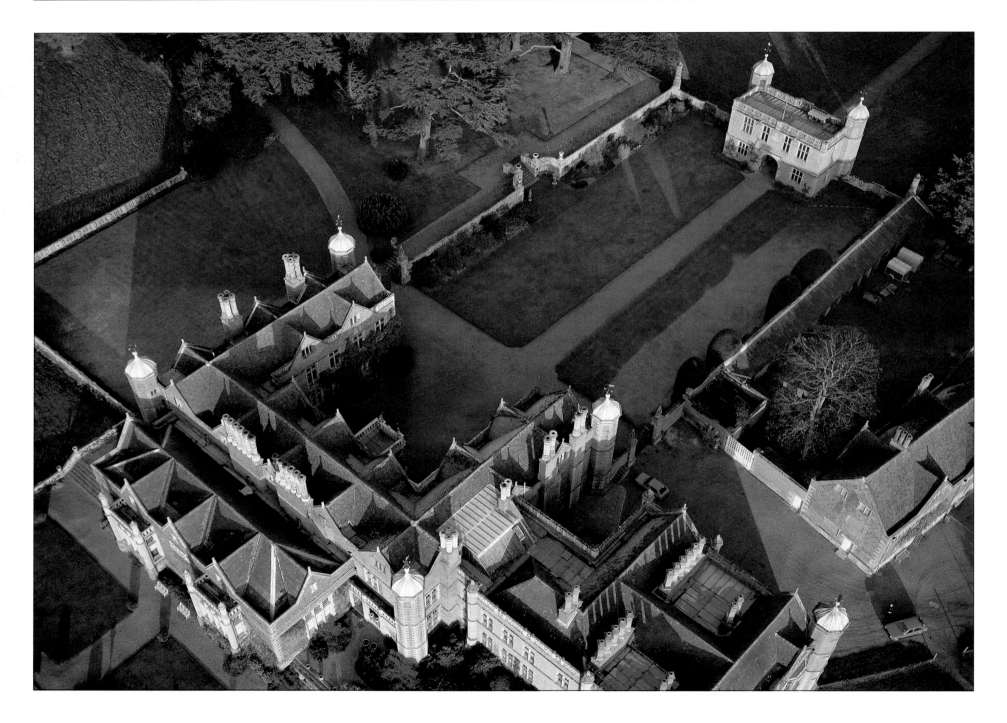

◄ CHARLECOTE PARK

William Shakespeare, so the story goes, came here from Stratford-upon-Avon to poach deer in the park. He was caught and brought before Sir Thomas Lucy, the owner of Charlecote and local magistrate. Shakespeare fled Warwickshire for London. In revenge for his treatment, he is supposed to have used Sir Thomas Lucy as a model for the ridiculous figure of Justice Shallow in The Merry Wives of Windsor. *The Elizabethan appearance of the main part of the house is the result of extensive remodelling in the 19th century. Of the original Tudor building, only the gatehouse, seen top right in this photograph, survives unaltered.*
THE NATIONAL TRUST

BLICKLING HALL ►

The south front of Blickling Hall looks out over a broad expanse of lawn framed by splendid yew hedges. When Sir Henry Hobart bought Blickling, probably in 1616, he decided to remodel it. The initials R.L. on the south porch reveal that Robert Lyminge carried out the work. Lyminge also designed Hatfield House and the two houses share several features: curving gables, corner turrets capped with cupolas, pierced strapwork and the use of brick set off by courses of stonework. There is a landscape park to the north of Blickling and the open Norfolk countryside unfolds in the distance.
THE NATIONAL TRUST

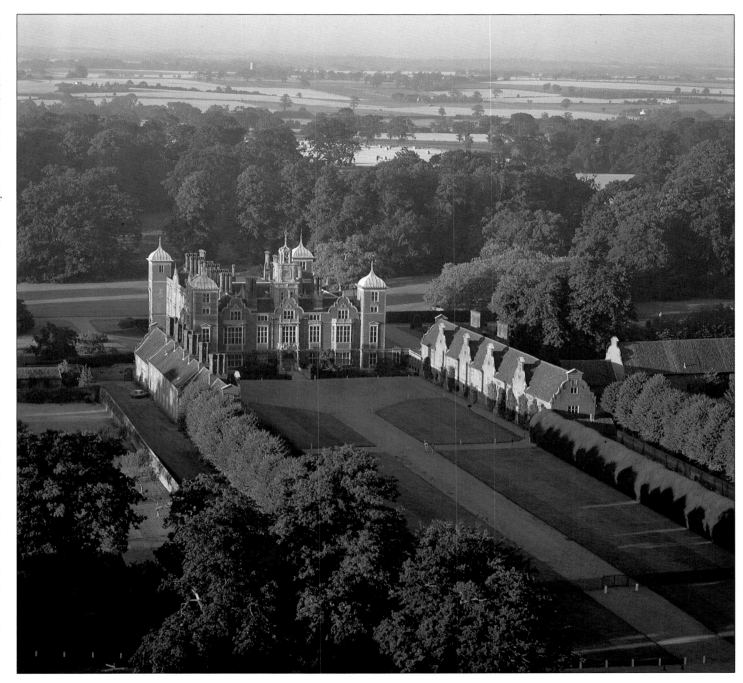

KINGSTON LACY

This is the only surviving house designed by Sir Roger Pratt, a gentleman architect who had avoided the English Civil War by travelling abroad. Sir Roger returned with a detailed knowledge of current European style, which he incorporated in the designs for his house in Dorset. He was a pioneer of Renaissance architecture and perhaps the most influential architect of his day. The house at Kingston Lacy was built between 1663 and 1665. Unfortunately, the roof line was destroyed in the 18th century. In the 1830s Sir Charles Barry was called in to restore some of the 17th century character and he faced the house of red brick with stone. The south front looks out over striped lawns towards the Egyptian obelisk, dated around 150 BC. Hieroglyphs record that this was set up by priests at Philae, as a memorial to their exemption from paying taxes.
THE NATIONAL TRUST

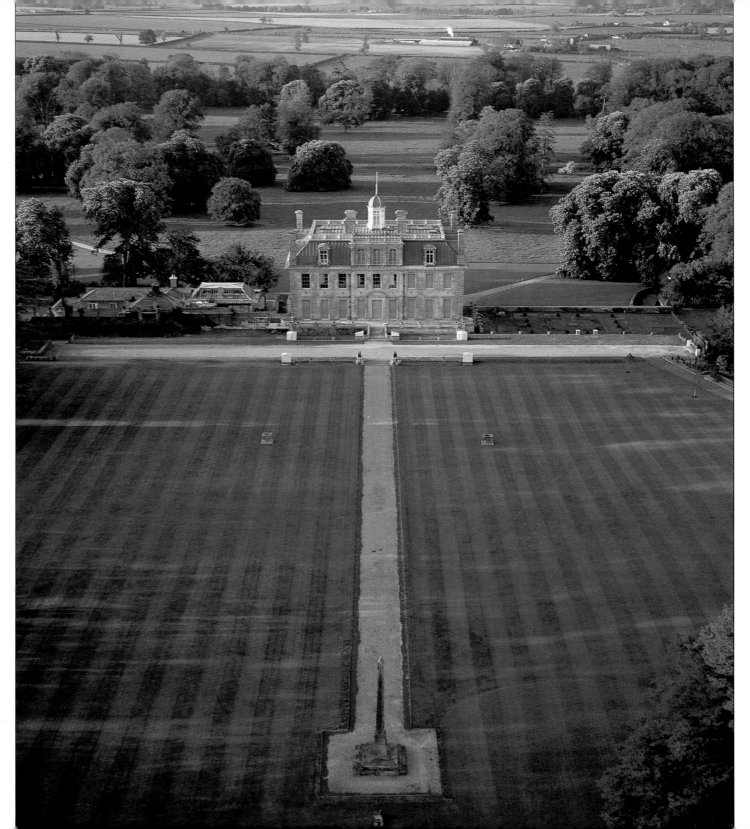

100

CANONS ASHBY

Canons Ashby in Northamptonshire was the home of the Dryden family from the mid-16th century until 1980, when it was acquired by The National Trust. Of the original 16th-century house, the most noticeable feature is the tower which sits in the middle of the west front. Most of what we see today was built between 1708-1710 by Edward Dryden, the cousin of the Poet Laureate. He rebuilt the south front in stone, and replaced the earlier mullioned windows with sashes. He also laid out the formal garden, with its series of terraces and flights of steps, enclosed by stone walls and grand Baroque gates. Few houses have survived the changing tastes of the last two and a half centuries better than Canons Ashby, and we are particularly lucky that the formal gardens escaped the fashion for landscaping in the later 18th century.

THE NATIONAL TRUST

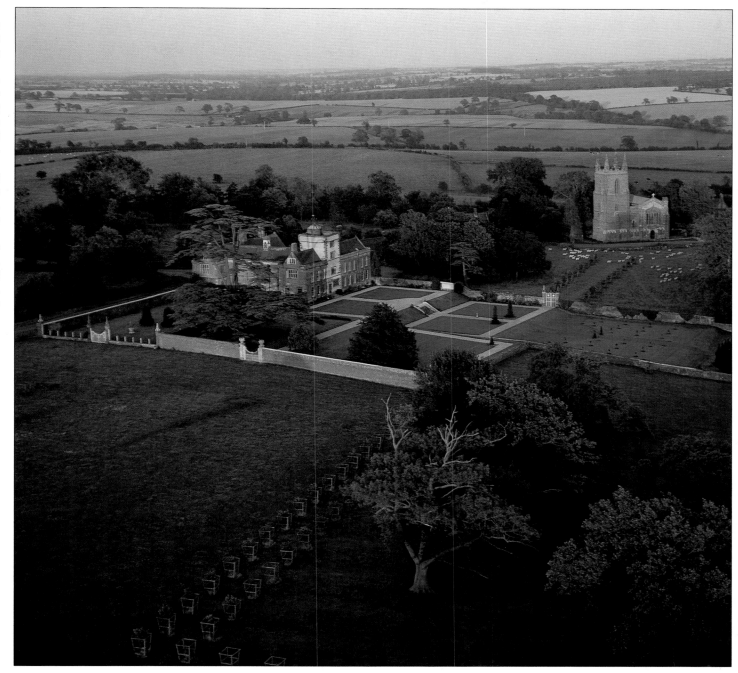

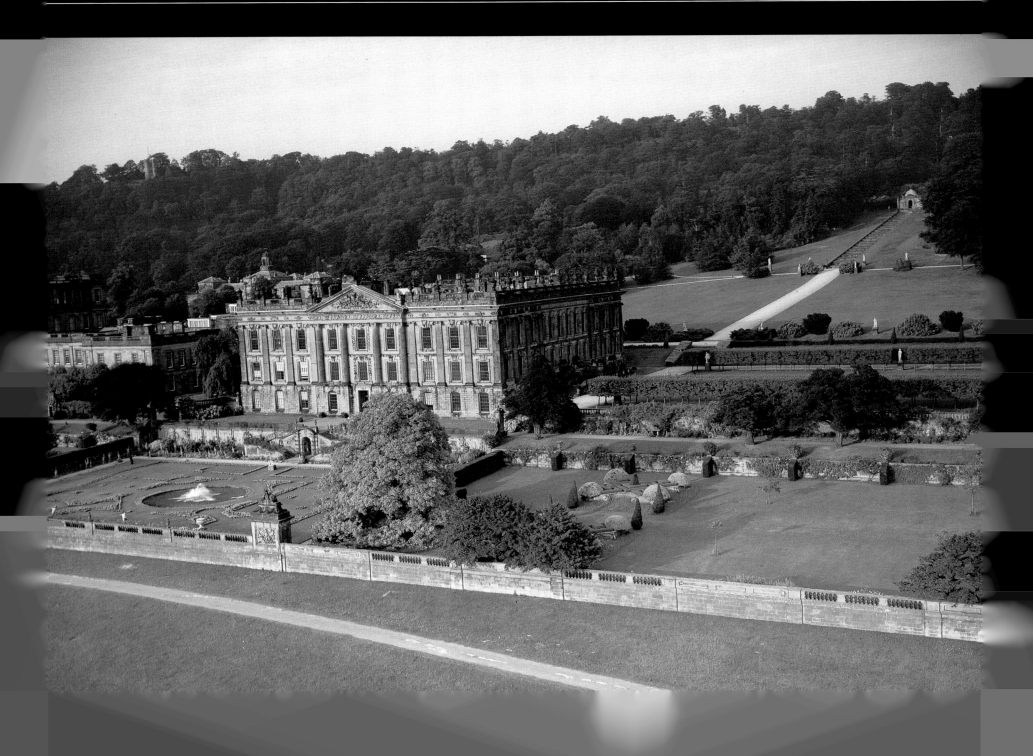

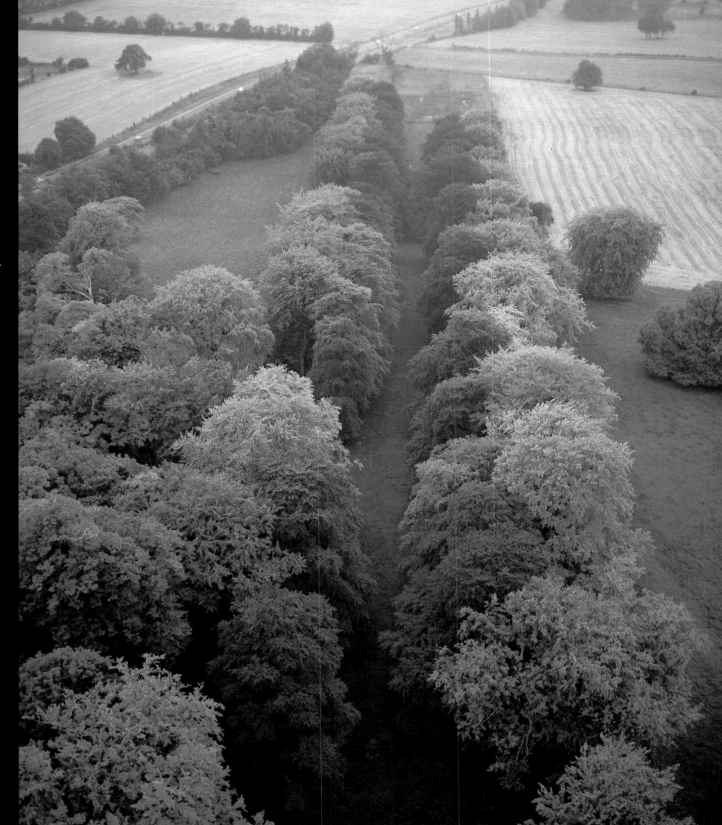

◄ CHATSWORTH HOUSE

The west front of Chatsworth House in Derbyshire, its golden sandstone glowing on a summer evening, looks out over the terraced garden to the park beyond. Originally an Elizabethan mansion, Chatsworth was remodelled by the first Duke of Devonshire. The south front, built in 1689 to William Talman's design, marked an early appearance of the new Baroque style in an English country house. The west front was probably designed by the Duke himself, perhaps with the help of Thomas Archer. Archer probably also designed the charming little house (seen top right) at the head of the famous Cascade, an escalator of water running down a flight of steps. The Cascade was part of the vast and complex formal gardens. Most of these were altered by the fourth Duke, who had Capability Brown landscape the gardens and park in the new "natural" style of the 1760s. A return to formality has been made by the present Duke and Duchess, who planted the west front garden (seen bottom left) to a design taken from one of Lord Burlington's ground plans for his Palladian villa at Chiswick.

CLANDON PARK ►

Beech alternates with copper beech in all that survives of the great avenues that existed at Clandon Park in Surrey until the 1770s. Leonard Knyffe's view of Clandon Park, painted in about 1720, shows that there was originally an elaborate formal garden with three grand avenues radiating out from the west front of the house.
THE NATIONAL TRUST

CASTLE HOWARD

Castle Howard "started out as a scribble on a piece of paper in a gentleman's club", to quote the advertising for one of the great Baroque houses in England. Charles Howard, the third Earl of Carlisle, commissioned his fellow club member, the soldier and playwright John Vanbrugh, to design a completely new house on his Yorkshire estate. It was Vanbrugh's first commission. He was unknown as an architect, and he turned to Nicholas Hawksmoor for assistance with the details of the design. Work started in 1700. In Vanbrugh's original plan the two wings were to be symmetrical, both joined to the house by a curved arcade. In the aerial view (far right), this symmetry is noticeably lacking. After Vanbrugh's death in 1726, the west wing (seen on the right in this photograph) was completed in an alien style by Carlisle's son-in-law, Sir Thomas Robinson. His wing lacks Vanbrugh's curved arcade; as a follower of Lord Burlington and the Palladians he wanted to introduce a more "correct" and restrained style. Castle Howard is the earliest landscape park with classical temples set in the grounds. The most striking of these is the Mausoleum (right) which Carlisle commissioned from Hawksmoor in 1720. There was a growing interest in archaeology, particularly in the classical world of Greece and Rome. Mausoleums take their name from the tomb built by King Mausolus at Halicarnassus, one of the Seven Wonders of the Ancient World. Hawksmoor turned to the models of Ancient Rome for the inspiration for this powerful, brooding design.

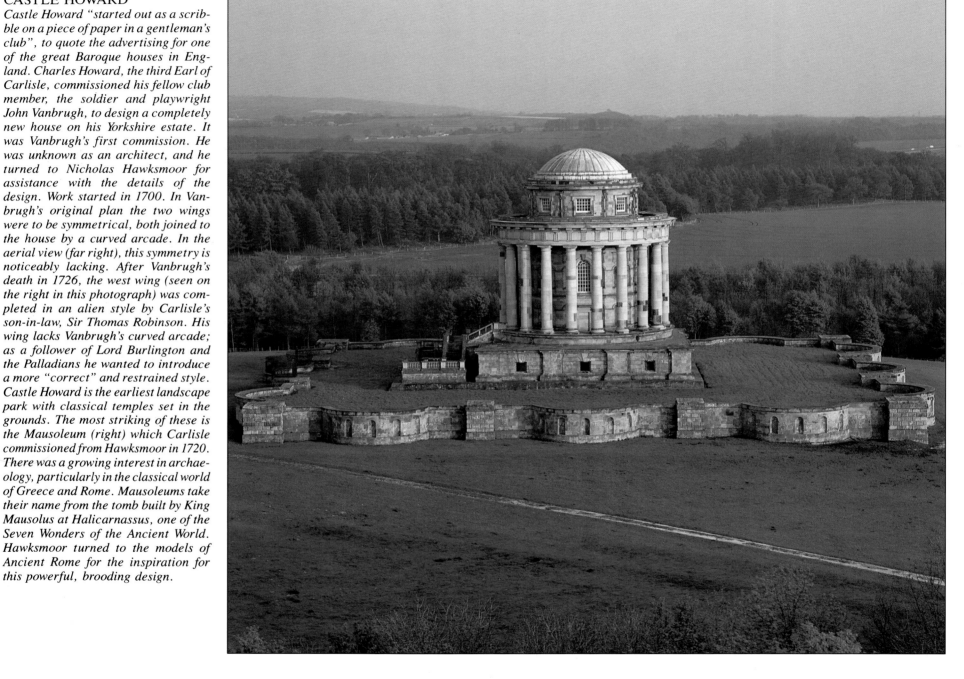

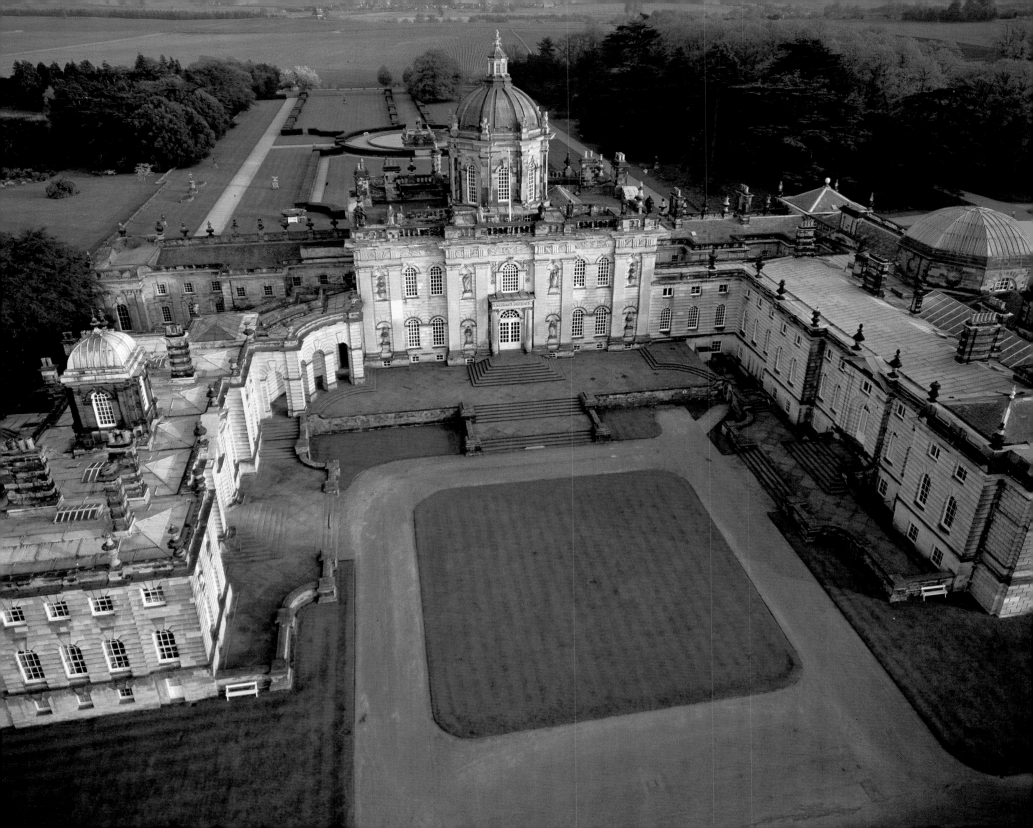

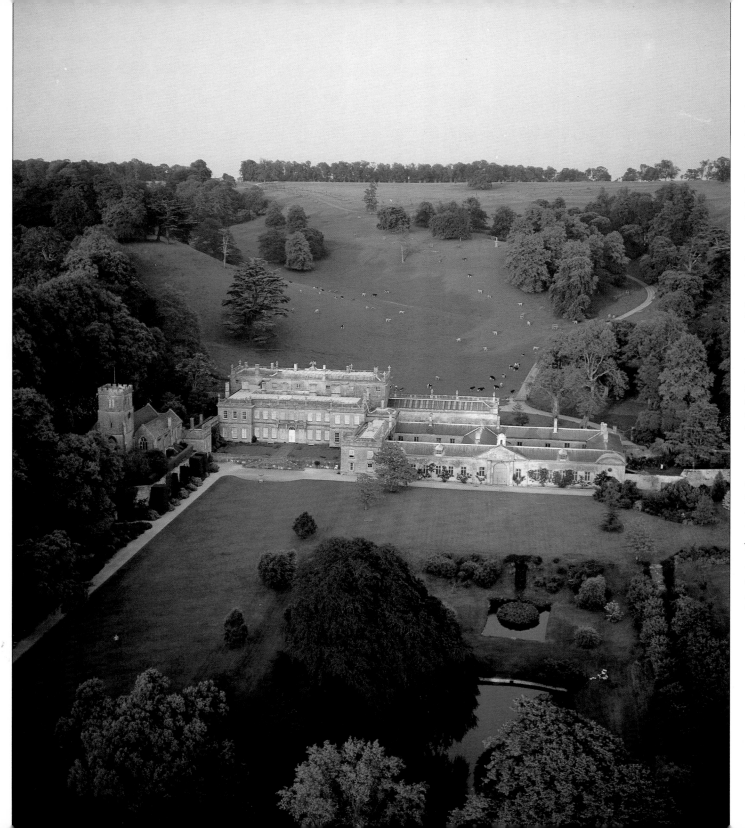

DYRHAM PARK

Dyrham Park in Avon, whose name reflects its origins as a deer park, was built between 1692 and 1700 for William Blathwayt, Secretary of State to William III. It stands at the foot of a steep escarpment, which used to be the setting for a famous formal garden. We know what this looked like from Leonard Knyffe's painting, which survives in the engraving by Johannes Kip (right). These bird's-eye perspectives by Knyffe and Kip were very popular at the beginning of the 18th century, and provide us with a fascinating record of many of the great gardens of this period. Knyffe's aerial views were done without the benefit of a balloon, relying instead on very careful surveying and measuring. Dyrham must have been particularly difficult, as the perspectives are complicated by the hilly terrain. A comparison with my photograph (left) shows how accurate he was. The hilly site provided the opportunity for a whole series of terraces and walks, as well as a Cascade similar to that at Chatsworth. A plentiful water supply also fed a quantity of fountains and other waterworks. In the late 18th century, the fashion for a more "natural" look led to the removal of most of this formal garden. The statue of Neptune, which used to be at the head of the Cascade, is still in place and so is one of the rectangular ponds, which can be seen bottom right in the photograph.
THE NATIONAL TRUST

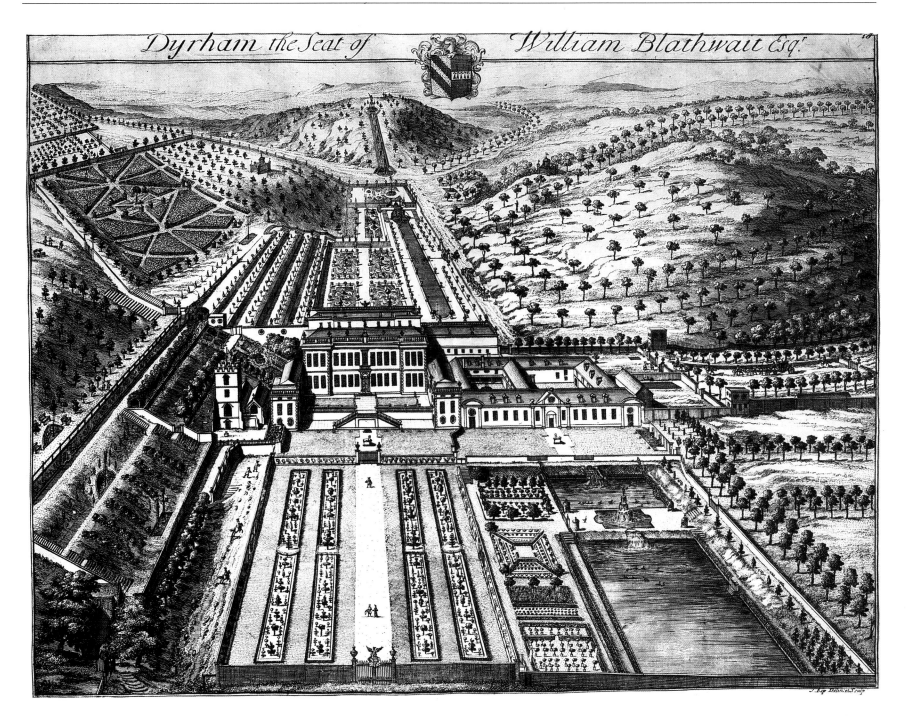

Dyrham the Seat of William Blathwait Esq.

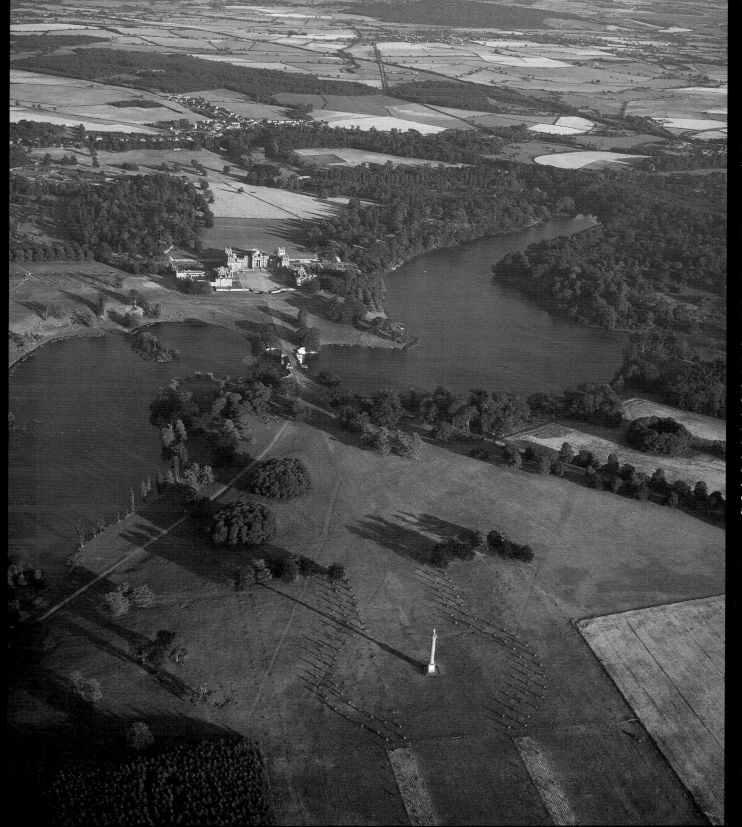

BLENHEIM PALACE

Blenheim Palace in Oxfordshire was built to commemorate the first Duke of Marlborough's victory over the French at the Battle of Blenheim in 1704. The plans, by John Vanbrugh assisted by Nicholas Hawksmoor, follow their work at Castle Howard: a central block is connected by curving colonnades to two projecting wings, forming a magnificent courtyard on the north front. The skyline is made up of a broken pediment crowned by glittering gold orbs and ducal coronets. In the Park, the two lakes, divided by Vanbrugh's great bridge, were created in the 1760s when Capability Brown flooded the River Glyme. Brown also created the lawns and vistas by the planting of clumps of trees. Vanbrugh did not have an easy time working for the Marlboroughs. He quarrelled with the Duchess, who had a low opinion of architects, "knowing none that are not mad or ridiculous". Eventually, she refused to let him enter the grounds to see the finished Palace. Blenheim is the last of the great Baroque houses with their three-dimensional sculptural effects. The next generation of patrons and architects preferred a more austere style.

COLUMN OF VICTORY

The Grand Avenue at Blenheim leads from Vanbrugh's bridge to the Column of Victory, crowned by the figure of the Duke of Marlborough in the trappings of a Roman general. He looks along the line of the Avenue towards the Palace. Tragically, the Avenue had to be replanted in the 1970s after Dutch Elm disease destroyed most of the trees.

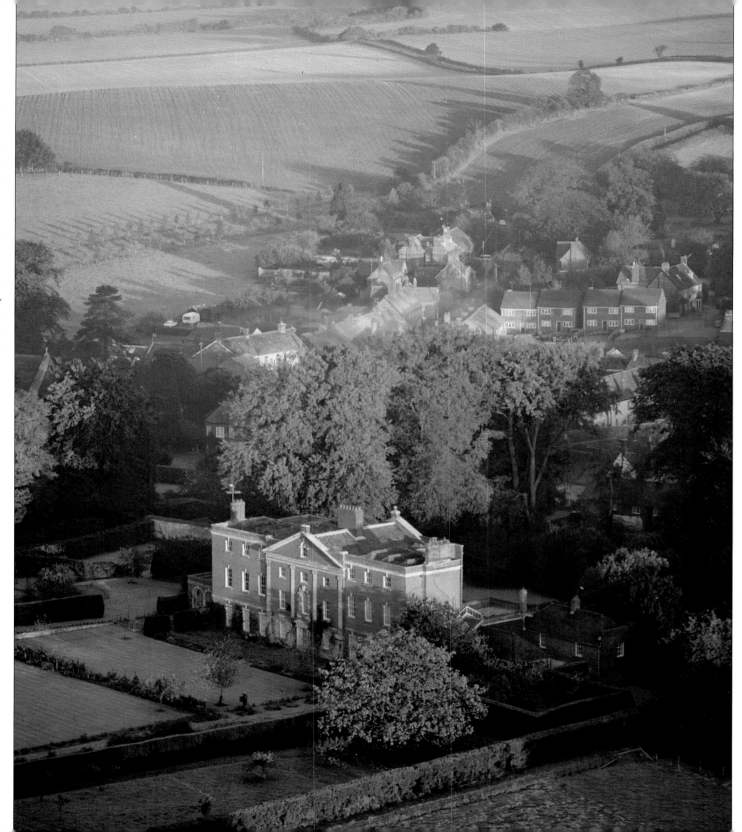

◀ STUDLEY ROYAL

At Studley Royal the Temple of Piety looks out across the Moon Pool, while a Gothic tower and a Rotunda nestle in the woods above. These delightful water gardens were created by John Aislabie in the 1720s. He had been involved in the financial scandal of the South Sea Bubble and retreated to Yorkshire to transform a stretch of the River Skell into a landscape of ponds and canals, embellished with temples and fountains. The location, next to the ruins of Fountains Abbey, was at the bottom of a steep valley and required moving considerable quantities of earth. The woodland setting and antique temples look forward to the picturesque garden at Stourhead, but the geometrically shaped pools and straight canals are closer in style to earlier formal gardens.
THE NATIONAL TRUST

CRANBORNE LODGE ▶

Cranborne Lodge was originally built in the early 18th century by the Stillingfleet family, who managed the large Dorset estates of the Earls of Salisbury for several generations. The central block of the house may have been the work of the Bastard brothers, who contributed so much to the nearby town of Blandford, rebuilt after fire in the 1730s. The house was remodelled in the 1750s, when the wings on the south front were added by a new owner, Thomas Erle Drax. The difference in height between the windows in the main block and the two wings is very noticeable. The slender Ionic pilasters which support the central pediment are probably early 19th century.

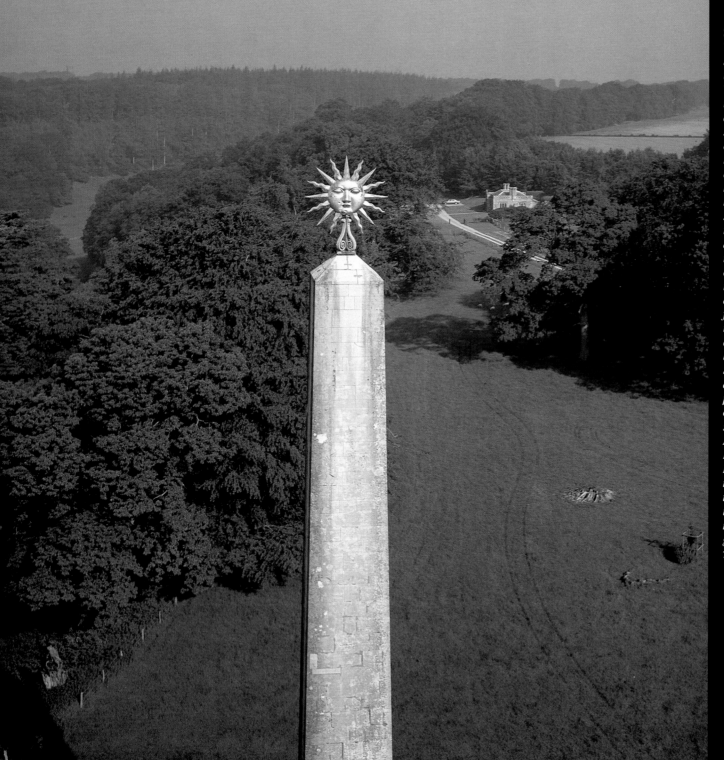

STOURHEAD
The thrill of drifting across the lake at Stourhead on a calm summer's morning made this an unforgettable flight. The gentlest of winds carried me past the glowing sun on the obelisk (left), and down over the surface of the water. As I floated among the trees, I caught enthralling glimpses of the Pantheon reflected in the lake (right). Part of the excitement was knowing that nobody had ever seen Stourhead like this before. The garden was intended to be seen as a series of picturesque views that open up and recede as you stroll around the lake. The circuitous walk takes you into an enchanted world of cascades, grottoes, bridges, rocks, river gods and classical temples. There are surprises here at every turn, and I felt privileged to experience these in a new way. This magical world was the creation of Henry Hoare, heir to a banking fortune. He started work at Stourhead in 1741. The temples were designed by Henry Flitcroft, but the planning of the garden was Hoare's own. He drew inspiration from many sources, including the buildings of Ancient Rome, and the 17th-century French landscape paintings of Claude Lorrain and Gaspar Poussin. The result is a perfect example of the new type of English landscape, where irregular, curving lines replaced the rigid geometry of the French formal garden. (See also page 114.)
THE NATIONAL TRUST

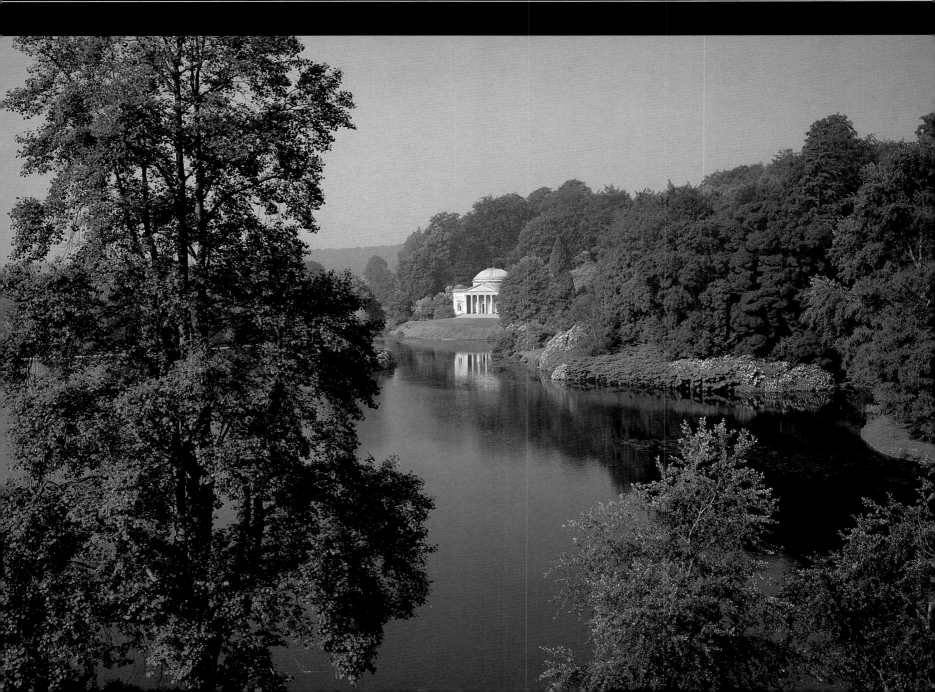

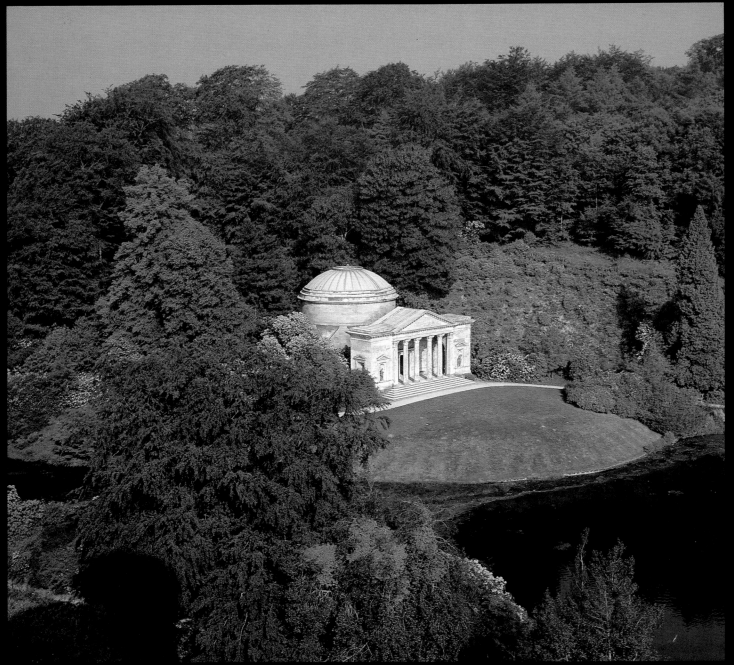

◄ THE PANTHEON, STOURHEAD

The Pantheon in Rome is a circular temple with a pedimented portico, and a domed roof with a circular opening in the centre. When Henry Flitcroft was commissioned to design a temple at Stourhead in Wiltshire he followed the Ancient Roman model. But the setting of the two buildings is worlds apart. The Roman Pantheon is in one of the busiest squares in the city, while at Stourhead its namesake overlooks the idyllically tranquil gardens created by Henry Hoare in the 1740s. (See also pages 112-113.)
THE NATIONAL TRUST

WIMPOLE HALL ►

The present appearance of Wimpole Hall, the most spectacular country house in Cambridgeshire, is the work of Henry Flitcroft. He was engaged by Lord Hardwicke to modernize Wimpole; he re-designed the central section of the south front and faced the entire building in brick. Known as "Burlington Harry" because of his association with Lord Burlington, Flitcroft produced a design that is typically Palladian in its quiet restraint and elegant proportions. Sadly, one of the glories of Wimpole, an avenue of elms over three miles long, fell victim to Dutch Elm disease in the 1970s.
THE NATIONAL TRUST

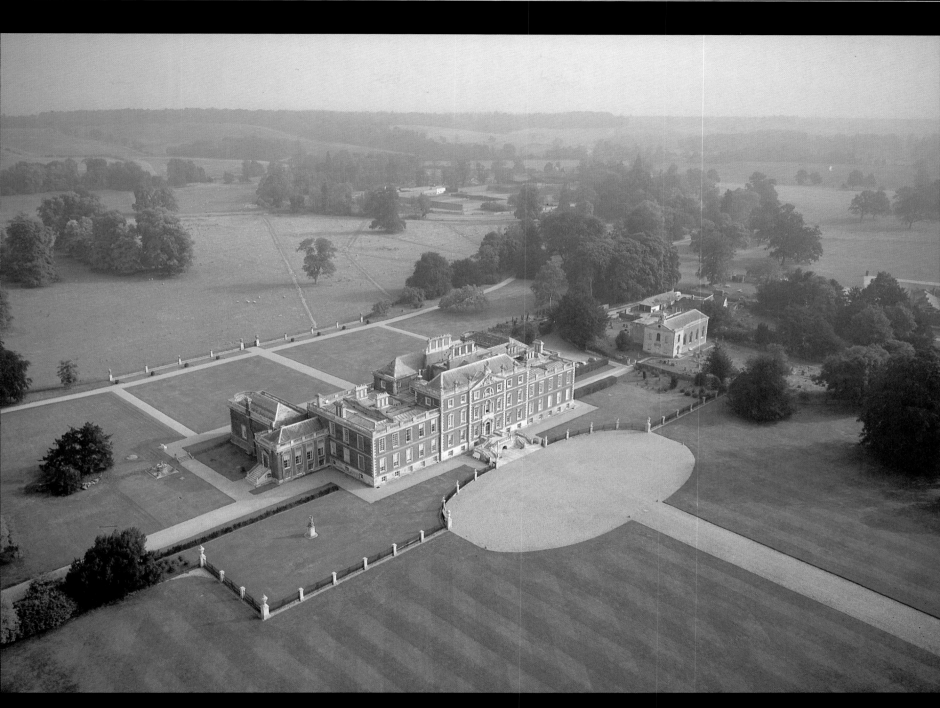

KEDLESTON HALL

This view of Kedleston Hall in Derbyshire shows Robert Adam's south front, which was built in the 1760s for Nathanial Curzon, later Lord Scarsdale. With its use of classical ornament (notice the swags between the capitals on the central section), it is a perfect example of the neo-classicism which Robert Adam was to establish as the accepted style of the later 18th century. Adam aimed at a sense of "movement" which here at Kedleston is provided by the contrast between the curves of the staircase and dome. Adam followed the identical principles of movement of "rise and fall" when he designed the park, which is equal to anything by Capability Brown. All the features are here: a belt of woodland enclosing a park, clumps of trees, a meandering river in the middle distance, a bridge with a cascade – adding up to one of the most beautiful landscapes in England. To get this shot of Kedleston, I launched my balloon from a field next to the house. As soon as I was airborne the wind direction changed, taking me straight towards East Midlands Airport, so I landed immediately. My passenger offered to go and see the farmer whose field I had landed in. Unfortunately a young horse was so frightened by the noise of my burners that it jumped a barbed wire fence and ran off down the road. Its owner was understandably furious. She gave my friend a severe ticking off, but finally relented a little, saying, "Well at least you've shown me how well she jumps. If she goes on like that she'll make a great little lady's hunter."
THE NATIONAL TRUST

PETWORTH

To stroll in the great park at Petworth is to travel back in time. The last two centuries have dealt kindly with Capability Brown's masterpiece where, more fully than anywhere else, we can appreciate the nature and scale of his genius. He divided the park into different zones, using the natural lie of the Sussex land to full effect. Near the house he laid out smooth lawns, then created a lake to fill the middle distance. Beyond this there is a long valley, while on the skyline is a belt of woodland. The eye is led through the composition by clumps of trees which are strategically grouped on the broad sweep of open grass, now grazed by herds of deer. This beautiful landscape inspired some of Turner's finest paintings, which can still be seen in the house. On this flight from Petworth we inadvertently flew low over a pig farm. The noise from the burners alarmed the pigs, which ran amok and several escaped. We climbed rapidly, to a barrage of curses from the pig farmer. We did our best to make ourselves scarce by flying as high as possible. Forty minutes and eight miles later, we landed, to find the pig farmer's wife, in a smart red BMW, blocking our exit from the field. She took our names and addresses, and the pig farmer sent a hefty claim for damages. Why is it that your retrieve driver usually fails to find you, but that less welcome pursuers never seem to have a problem?

THE NATIONAL TRUST

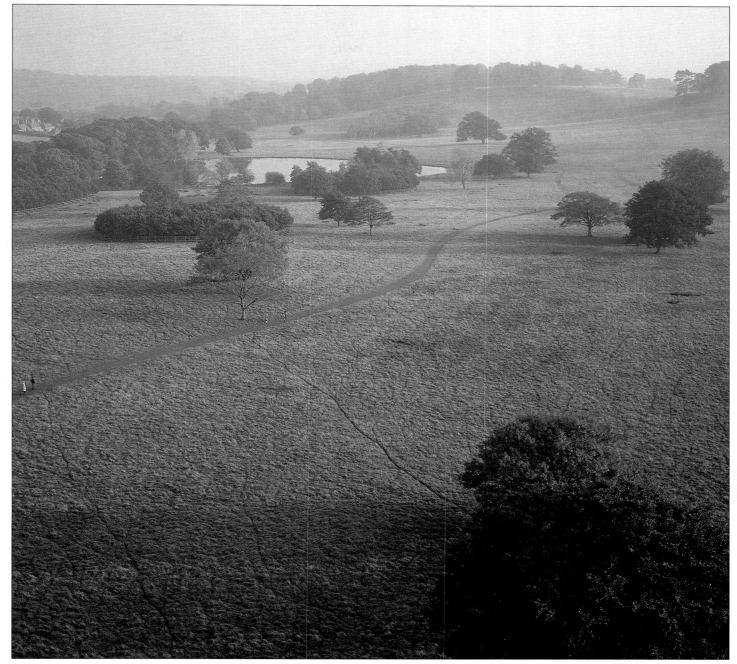

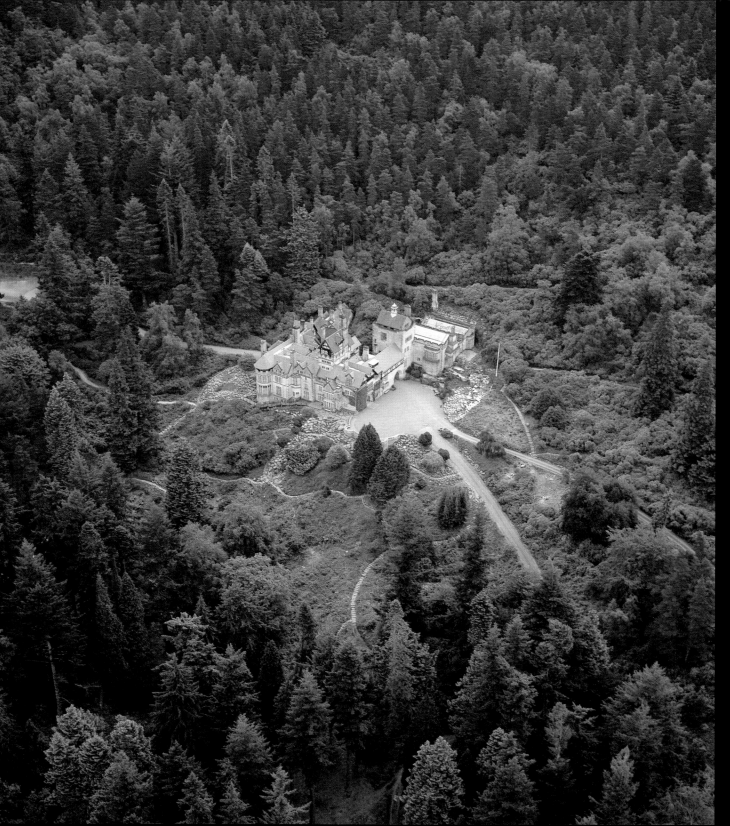

◄ CRAGSIDE

On a morning flight whose purpose was more fun than photography, the Victorian mansion of Cragside just appeared over the brow of a hill. Sir William Armstrong, who had made a fortune out of hydraulic cranes and another out of the Armstrong gun, planned to build a small lodge here by the River Coquet in Northumberland. Norman Shaw was engaged as his architect and by 1884, when he had finished building at Cragside, the house had grown in all directions. Sir William was keen to make Cragside as up to date as possible. His own hydraulic machinery drove a lift, the central heating and the kitchen spit. A water turbine provided the power for the electric lights; Cragside was the first private house in England, perhaps in the world, to be fully lit by electricity. By the time Armstrong died in 1900 the grounds at Cragside covered more than 1700 acres and had been planted with seven million trees.
THE NATIONAL TRUST

BRYANSTON ►

One of the last of the very large English country houses, Bryanston in Dorset was designed by Norman Shaw in the 1890s for Lord Portman, whose enormous wealth came from his estates in the West End of London. The style, a monumental version of Christopher Wren, is far removed from the fantasy of Shaw's earlier work at Cragside. It was said of Shaw that he wore very large cuffs when he went out to dinner: he used these to sketch out designs for houses during the meal, hoping to secure new clients among his fellow diners.

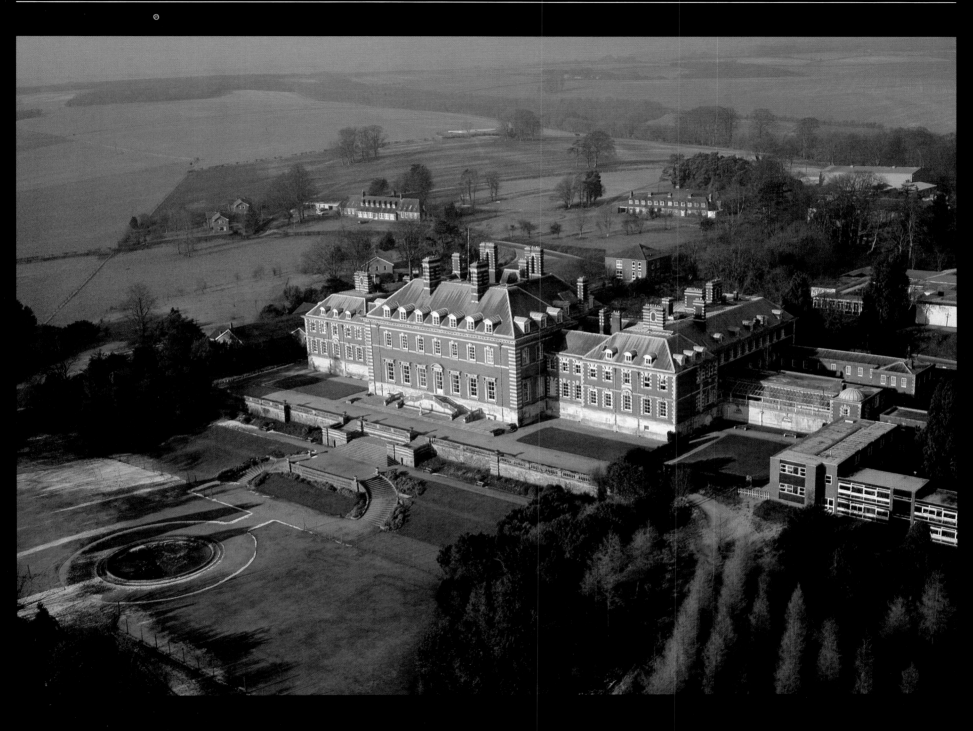

NOTES ON NATIONAL TRUST PROPERTIES

The following information has been provided by The National Trust. Please refer to The National Trust Handbook for opening times.

ASHDOWN HOUSE
Lambourn, Newbury, Berkshire
Ashdown House was consecrated by William, first Earl of Craven, to Elizabeth of Bohemia, the "Winter Queen". The chivalrous Earl devoted his life, money and emotions to her and even took up arms on her behalf. Ashdown was probably built for the queen as a refuge from plague-ridden London, but tragically she died in 1662 before the house was finished. In 1956 Countess Craven gave Ashdown House to the Trust in a near-derelict state. The Trust restored the house so that it is once more fit for a queen.

BLAKENEY POINT
Cley-next-the-Sea, Norfolk
Blakeney Point was acquired for the Trust in 1912 and was the first nature reserve to be established in Norfolk. The Point is an important breeding ground for birds, including terns, oystercatchers and plovers.

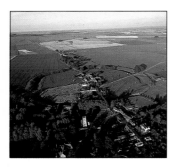

AVEBURY
near Marlborough, Wiltshire
Pagan prehistory is inextricably linked with the present at Avebury. The village is built partly within the Neolithic stone circle, a fact which caused conflict in the Middle Ages, when the villagers tried to destroy many of the sarsen stones. The co-habitation is much more harmonious today, with the Trust looking after the stones.

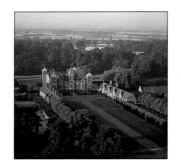

BLICKLING HALL
Norwich, Norfolk
This mellow red brick house was built in the 1620s and is now considered a masterpiece of Jacobean architecture. It has not always been seen in such a favourable light; a valuation of 1756 put its price at little above the salvage rate of its building materials. Fortunately, architectural fashions changed soon after that and Blickling was not demolished. Blickling was given to the Trust in 1940 under the newly established Country House Scheme, so its future is now assured.

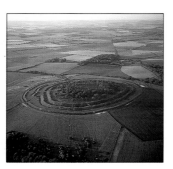

BADBURY RINGS
Wimborne Minster, Dorset
The Iron Age hillfort at Badbury Rings, with its Bronze Age burial mounds and Roman remains, came to the Trust as part of the Kingston Lacy estate in 1982.

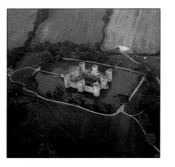

BODIAM CASTLE
near Robertsbridge, Sussex
The great 14th-century moated castle of Bodiam has been in ruins since the Civil War when Parliamentary troops dismantled the interior. Since then it has passed through the hands of a succession of local families who wanted to save it from destruction. Finally, in 1916, the Marquess Curzon of Kedleston bought the castle, excavated and repaired the ruins, and bequeathed it to the Trust in 1925.

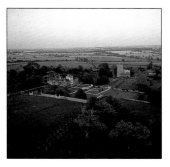

CANONS ASHBY
near Daventry, Northamptonshire
An Augustinian priory existed at Canons Ashby from 1150 until 1537. By 1573 the house had become home to John Dryden, and wall paintings dating from this period have been uncovered by the Trust in the Winter Parlour. A later John Dryden, the Poet Laureate, was a frequent visitor to Canons Ashby in the 1650s, when he was courting his cousin Honor.

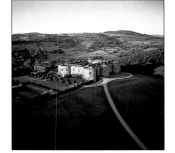

CHIRK CASTLE
Chirk, Clwyd, Wales
In 1595 Chirk was bought by the merchant adventurer Sir Thomas Myddleton, one of the founders of the East India Company and patron of Drake, Raleigh and Hawkins. The Myddleton family have lived at Chirk ever since, but in 1981 the castle passed into the care of The National Trust to ensure its continued survival.

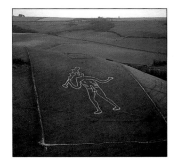

CERNE GIANT
Cerne Abbas, Dorset
The Cerne Giant is a 180-foot fertility symbol cut into the chalk hillside near Dorchester. He dates from the second century AD. The Giant was given to the Trust in 1920 and was an early example of the Trust acquiring a site for its archaeological interest rather than its scenic beauty.

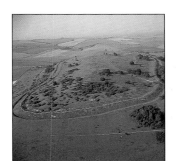

CISSBURY RING
near Findon, Sussex
In 1924 the Trust appealed for £2000 to buy Cissbury Ring, an important archaeological site and area of outstanding natural beauty. More land around the hillfort has been bought for the Trust in recent years.

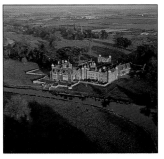

CHARLECOTE PARK
Wellesbourne, Warwickshire
Sir Thomas Lucy entertained Queen Elizabeth at Charlecote in 1572, and later had the encounter with William Shakespeare described on page 99. The house was remodelled in the early 19th century to make it appear once more like an Elizabethan house, at least in the eyes of its Victorian owners. In 1945 Charlecote was presented to the Trust by Sir Montgomerie Fairfax-Lucy, whose nephew still lives there.

CLANDON PARK
West Clandon, Guildford, Surrey
Clandon Park has been home to the Onslow family since 1641, and the seventh Earl still lives on the estate. When the house was given to the Trust in 1956 it was practically empty, but a bequest from Mrs David Gubbay of a fine collection of 18th-century English furniture, textiles and English, continental and oriental porcelain enabled the Trust to refurnish Clandon.

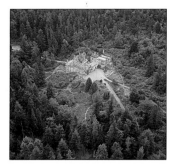

CRAGSIDE
Rothbury, Morpeth, Northumberland

The modern visitor to Cragside steps back into the world of the wealthy Victorian industrialist, Sir William (later Lord) Armstrong. He entertained important clients there, including the King of Siam and the Shah of Persia. The royal guests must have been impressed by the electric lights, as Cragside was probably the first house in the country to be lit by hydro-electricity. The Trust has recently restored Armstrong's machinery to working order.

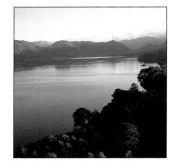

DERWENTWATER
Cumbria

In 1902 the Trust acquired its first countryside property in the Lake District. This was Brandelhow, 108 acres of wood and parkland on the shores of Derwentwater. The Trust now owns over 140,000 acres, or over a quarter of the Lake District. In accordance with the wishes of the Trust's founders, this land must be conserved for future generations, but also made accessible to visitors, who now total about 11 million a year.

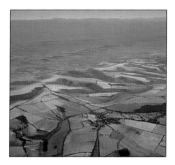

CRANBORNE CHASE
near Shaftesbury, Dorset/Wiltshire

Win Green Hill, the highest point on Cranborne Chase, has belonged to the Trust since 1937. From this commanding viewpoint, on a clear day, it is possible to see as far as the Isle of Wight and the Quantock Hills.

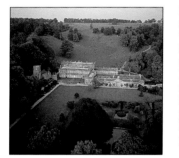

DYRHAM PARK
Chippenham, Avon

When William Blathwayt married the heiress to Dyrham in 1686 he gained a Tudor manor house, but soon decided to rebuild it into the Baroque house that we see today. His taste was influenced by the Dutch style made fashionable in England by William III and Mary. The house is still adorned with Blathwayt's collection of bird paintings by Hondecoeter, Delft porcelain and other Dutch furnishings acquired during his diplomatic postings to Holland.

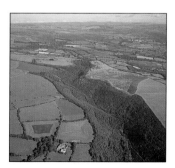

DARTMOOR
Devon

Over the past thirty years, the Trust has acquired vast tracts of Dartmoor, including many prehistoric monuments. In the south of the moor the Trust's holdings include the Trowlesworthy, Willings Walls and Hentor Warrens. Here rabbits were bred for their flesh and fur from medieval times to the 1950s. Farmers on the moor today use these areas for sheep, cattle and ponies, rabbits having become a nuisance rather than a cash crop.

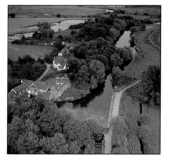

FLATFORD MILL
East Bergholt, Suffolk

Flatford Mill, on the River Stour, features in some of John Constable's most famous paintings. His father owned the mill and John was apprenticed there before going to London in 1799 to train as a painter. The Trust now owns the mill which, along with other buildings on the Stour, is leased to the Field Studies Council, who run courses there to promote a better understanding and appreciation of the environment.

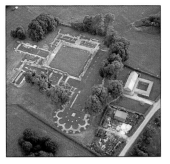

HAILES ABBEY
near Cheltenham, Gloucestershire

Hailes Abbey was one of the last Cistercian houses to be founded in England. The early monks led an unworldly life of austerity and prayer, but these ideals gradually faded, so that by the 15th century Hailes had become very wealthy. The museum on the site houses some of the treasures found at Hailes during the course of excavation.

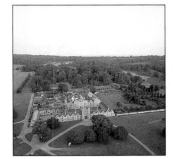

KNOLE
Sevenoaks, Kent

Vita Sackville-West spent her childhood at Knole, before moving to Sissinghurst with her husband, Harold Nicolson, in 1936. Her uncle, the fourth Lord Sackville, gave Knole to the Trust in 1946. On his death, in 1962, the furniture was acquired by the Treasury in lieu of death duties and placed under the care of the Trust. The present Lord Sackville still lives at Knole.

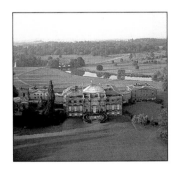

KEDLESTON HALL
near Derby, Derbyshire

Curzons have lived at Kedleston since 1150 and the present Viscount Scarsdale still occupies the family pavilion, having given the house to the Trust in 1987. Kedleston is largely the work of the Scottish architect Robert Adam, who also created the magnificent interiors and designed much of the furniture which can still be seen in the house.

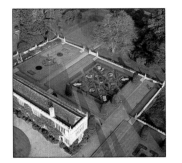

LANHYDROCK
Bodmin, Cornwall

When Lanhydrock burned down in 1881 Baron Robartes took the opportunity to create a more modest home for his large family. With its five staircases and interminable corridors it does not seem particularly convenient to today's visitor, but it demonstrates perfectly the social hierarchy in a late-Victorian country house, where people of different rank were not supposed to meet. Lanhydrock was given to the Trust in 1953 because the owner, Lord Clifden, wanted to save it from demolition, the fate overtaking many great houses at that time.

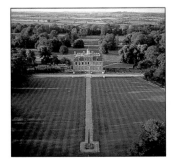

KINGSTON LACY
Wimborne Minster, Dorset

Sir John Bankes, Chief Justice to Charles I, bought the Corfe Castle and Kingston Lacy estates in the 1630s. Some 350 years later, in 1980, a descendant – Sir Ralph Bankes – bequeathed both estates to the Trust. The house is renowned today for its great art collection which includes family portraits by Lely and van Dyck, and Sebastiano del Piombo's great unfinished masterpiece, *The Judgement of Solomon*.

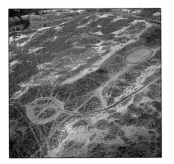

LONG MYND
near Shrewsbury, Shropshire

Archaeologists have proven that man has used the Long Mynd for over 3500 years. Bronze Age people left many tumuli close to the ridge and 1000 years later, during the Iron Age, small hillforts were built on the eastern flank. Since the 12th century, parts of the hill have been used as a sheep walk. Most of the moor is now common land owned by the Trust, but local farmers have grazing rights for their animals.

PETWORTH HOUSE
Petworth, Sussex

Petworth has been home to three great families: it belonged to the Percy Earls of Northumberland from 1150 until 1670 and then passed by marriage to Charles Seymour, Duke of Somerset; finally, in 1731, Charles Wyndham, second Earl of Egremont, inherited Petworth. His son, the third Earl, was a great patron of artists and he put together Petworth's famous collection of paintings and sculpture. A later Charles Wyndham gave Petworth to the Trust in 1947 and his grandson, the present Lord Egremont, still lives there.

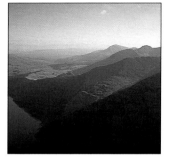

SNOWDONIA
Gwynedd

Some of the finest scenery in Snowdonia – such as the 15,000-acre Carneddau estate – is in the care of The National Trust. Carneddau, despite its size, is only one part of the Ysbyty property transferred to the Trust in 1951.

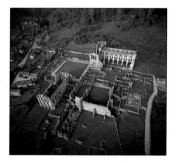

RIEVAULX
Helmsley, Yorkshire

The terrace at Rievaulx was constructed for Thomas Duncombe in the 1740s to afford a view over the ruins of Rievaulx Abbey. The serpentine terrace has a classical temple at each end, where the Duncombe family and their friends would picnic and admire the view. This view is little changed today and can still be admired from the terrace.

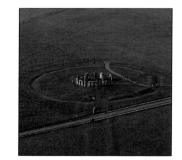

STONEHENGE DOWN
near Amesbury, Wiltshire

In 1918 the stone circle at Stonehenge was bought for the state, but the surrounding land stayed in private hands. There were fears that the impact of the stones could be ruined by insensitive development of the site, so the Trust launched a national appeal in 1927 and bought the land around the stones. The Trust's holdings include an impressive range of Beaker and Bronze Age barrow cemeteries dating from c. 2500-2000 BC.

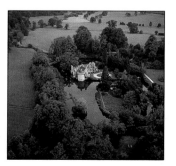

SCOTNEY CASTLE
near Tunbridge Wells, Kent

Scotney Castle was deserted shortly after 1817 when Edward Hussey died. His widow believed the house to be unhealthy and moved away with her son, another Edward. In 1837, he commissioned Anthony Salvin to build a new house and the old castle came to be regarded as a picturesque ornament in the garden landscape. Christopher Hussey, historian of the Picturesque movement, gave Scotney to the Trust in 1970.

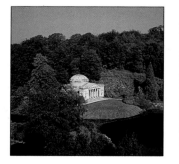

STOURHEAD
near Warminster, Wiltshire

When Sir Henry Hoare decided to create a family seat at Stourhead in the 1720s he was in a position to do so because of the banking fortune accumulated by his father, Sir Richard. The magnificent landscape gardens were laid out by Sir Henry's son, another Henry, who also collected the art treasures which are still housed at Stourhead. Stourhead came to the Trust in 1947 and it has always been a very popular property, receiving over 200,000 visitors a year.

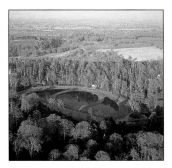

STUDLEY ROYAL
Ripon, Yorkshire
Studley Royal is the creation of two gifted amateurs: John Aislabie and his son William. John created the formal water garden between 1720 and his death in 1742. His son gave the garden a completely new dimension by purchasing the ruins of Fountains Abbey in 1768 and designing the informal approach to it from the garden. The Trust acquired the garden in 1983 and has now restored Studley Royal to its former glory.

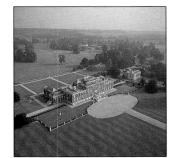

WIMPOLE HALL
Royston, Cambridgeshire
Edward Harley, second Earl of Oxford, patronised the greatest British artists and writers of his day: James Gibbs, Michael Rysbrack and Alexander Pope to name but a few. His library housed over 50,000 books and the walls of Wimpole were hung with magnificent paintings. But all this collecting bankrupted him and, just before his death in 1742, Wimpole was sold to pay his debts and his family had to sell his collections.

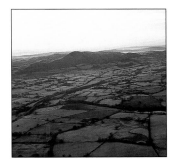

WENLOCK EDGE
Much Wenlock, Shropshire
Limestone from Wenlock Edge has always been a valuable source of building stone and lime for agricultural use and mortar. Old kilns for extracting the lime can be found all over the hillsides. The Trust has been gradually acquiring parts of Wenlock Edge since 1981 and is increasing public access to the area.

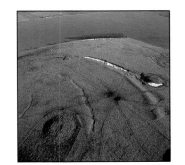

WINDMILL HILL
Avebury, Wiltshire
Windmill Hill is a 20-acre causewayed camp just north-west of Avebury. It predates Avebury by about 750 years and it is calculated that it would have taken 100 men about six months to construct.

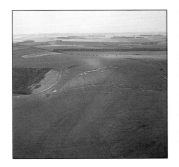

WHITE HORSE
Uffington, Berkshire
When the Trust was given White Horse Hill in 1979, it gained an important group of archaeological monuments: Uffington Castle, an Iron Age hillfort, Dragon Hill, where St George is said to have slain the dragon, and the white horse itself. The horse may well have marked the territory of a local Iron Age tribe, possibly the Dobunni from Cirencester or the Atrebates from Silchester. It is now a familiar landmark to walkers following the prehistoric Ridgeway along the Downs.

INDEX

Italicised folios indicate illustrations